Beginning
DRAWING

A multidimensional approach to learning the art of basic drawing

Walter Foster

Brimming with creative inspiration, how-to projects, and useful information to enrich your everyday life, Quarto Knows is a favorite destination for those pursuing their interests and passions. Visit our site and dig deeper with our books into your area of interest: Quarto Creates, Quarto Cooks, Quarto Homes, Quarto Lives, Quarto Drives, Quarto Explores, Quarto Gifts, or Quarto Kids.

© 2016 Quarto Publishing Group USA Inc.
Artwork and photographs © Alain Picard
"Nautilus shell" on page 92 © Shutterstock

First Published in 2016 by Walter Foster Publishing, an imprint of The Quarto Group.
6 Orchard Road, Suite 100, Lake Forest, CA 92630, USA.
T (949) 380-7510 **F** (949) 380-7575 **www.QuartoKnows.com**

Walter Foster Publishing titles are also available at discount for retail, wholesale, promotional, and bulk purchase. For details, contact the Special Sales Manager by email at specialsales@quarto.com or by mail at The Quarto Group, Attn: Special Sales Manager, 401 Second Avenue North, Suite 310, Minneapolis, MN 55401 USA.

ISBN: 978-1-63322-142-0

Cover Design: Jacqui Caulton
Design: Melissa Gerber

Printed in China
10 9 8 7 6

Table of Contents

Introduction

Learning to draw is much like learning to talk. Anyone can do it, but it takes time to develop the ability to communicate. Drawing is the foundational practice of learning to communicate through a visual language.

Through drawing we develop the building blocks of this visual vocabulary, learning how to transcribe marks and techniques and gain confidence in our ability to communicate. Growth happens as we put aside what we "know" about things, and see the world anew through artists' eyes. We discover that our powers of observation are often more trustworthy than our memory banks when describing the world around us.

If you are willing to open your eyes and your mind, then you can learn to draw. Through patient practice, your skill will develop. This happens one step at a time, often by learning one specific skill at a time. With persistent study, your drawings will begin to communicate with force and impact to the viewer. Like writers who arrange letters into words and form sentences, and musicians who hang notes on scales to release melodies and harmonies, the visual artist makes varying marks of line, tone, and color to create pictures.

Come along with me as we develop our visual vocabulary together by learning to draw. The journey is often very rewarding because practicing drawing is such great fun. I'm confident that your efforts will reap rewards and your creative voice will gain greater clarity and authority.

Now, let's begin.

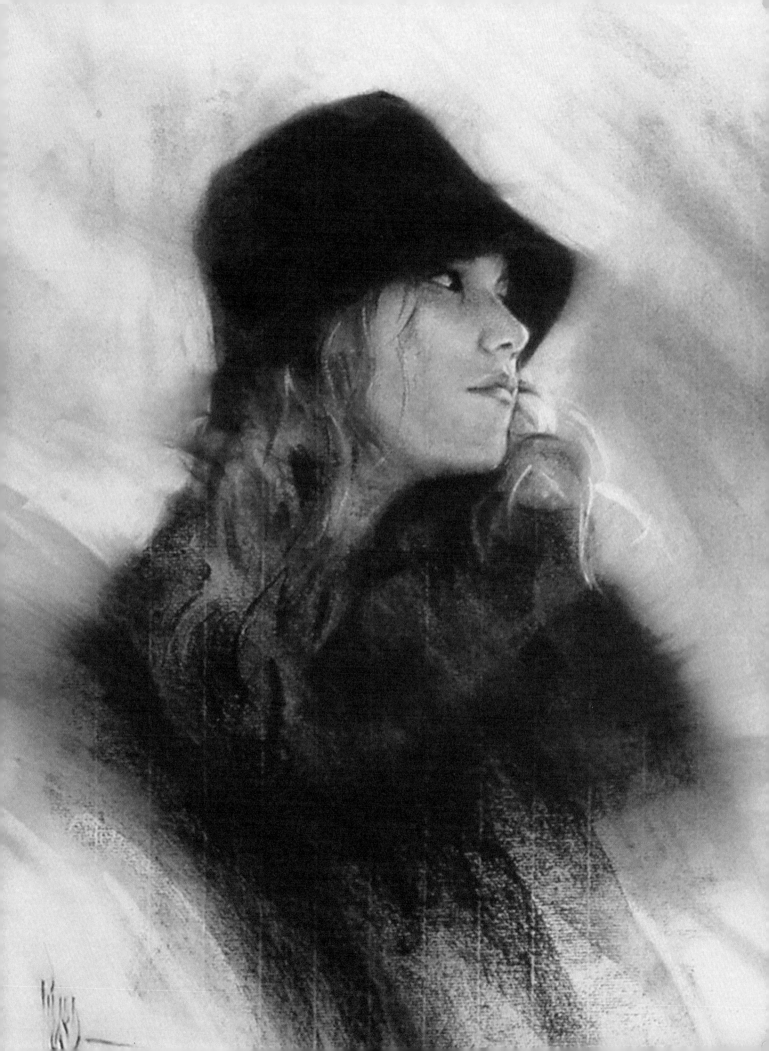

TOOLS & *Materials*

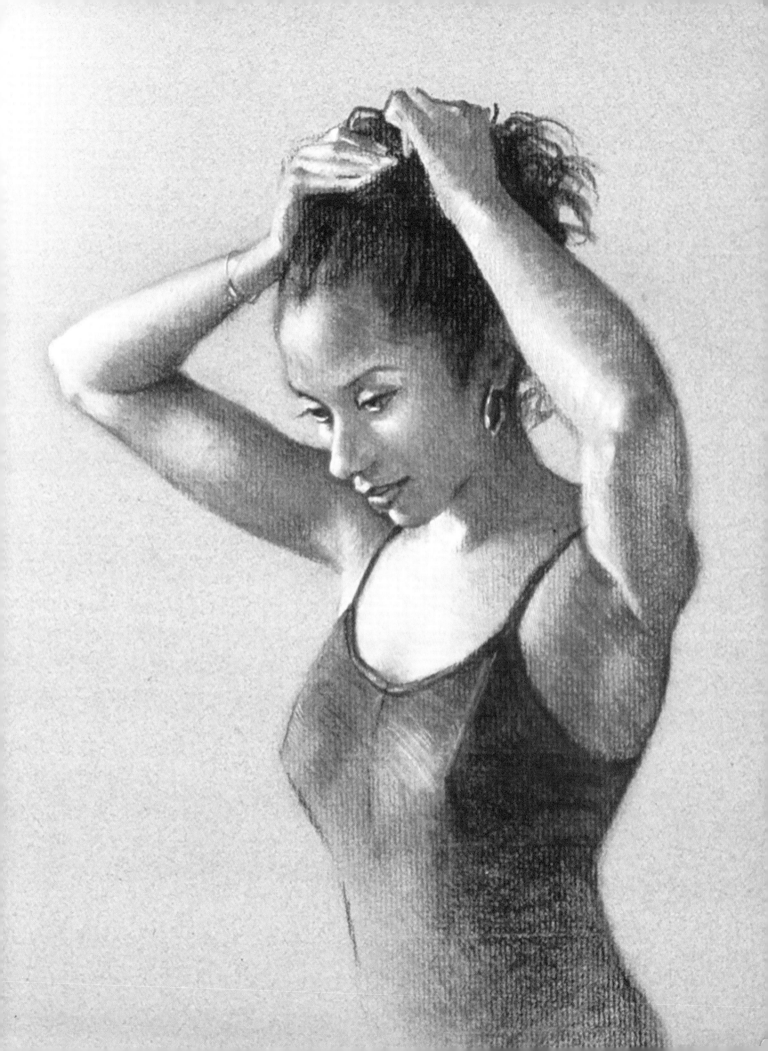

What You'll Need

It only takes a few simple tools to begin drawing, and they can be carried with you anywhere. Some tools are a must; others are optional and can be acquired later as you build upon your drawing techniques. Here are some of the materials that will set you off on your journey of learning to draw.

GRAPHITE PENCILS: The most basic tool is the pencil. Made of lead encased in wood, pencils come in a variety of densities—from hard (H) to soft (B)—and varying thicknesses. I recommend a simple set of six shades: H, HB, 2B, 4B, 6B, 8B. The extra-hard varieties run the risk of tearing your paper when used with a heavy hand. I prefer a softer spectrum of tones beginning with HB and moving to 8B.

ARTIST'S ERASERS: Erasers are used for far more than removing unwanted mistakes. They also create highlights, lighten tone, and clean up lines. Kneaded erasers can be molded into any shape for lifting out fine details and are equally effective with graphite and charcoal. Gum erasers lighten tone and clean up unwanted lines without staining or damaging the paper. The stiffer, white, vinyl erasers erase pencil lines while keeping the paper clean.

Gum erasers *Kneaded erasers*

SHARPENERS: Utility and X-Acto blades are tools for hand sharpening your pencils with a longer exposed lead that tapers slowly. I use a single-edge razor blade to sharpen my hard pastel sticks.

There are excellent electric pencil sharpeners available to save time, but I still love my little hand-held, German-made brass pencil sharpener. It's small and mobile—perfect for travel sketching. Be sure to purchase replacement blades to keep them working perfectly.

CHARCOAL: An excellent drawing tool for developing rich, velvety tones and soft edges, charcoal comes in many shapes, sizes, and densities. Vine charcoal sticks come in extra soft, soft, medium, and hard; in a variety of widths from thin to thick; and can be easily sharpened using a sandpaper block. Compressed charcoal is extremely hard and yields deep, rich blacks that are resistant to erasing. The square-shaped charcoal, called Nitram, is an excellent professional-quality stick that comes in extra soft, soft, medium, and hard.

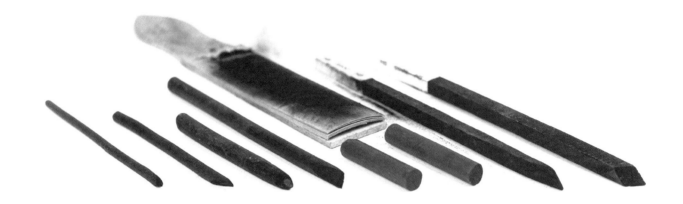

Left to right: vine charcoal, compressed charcoal, and Nitram charcoal, with sandpaper block

White charcoal, pastel pencils, and black Conté pencil on toned paper

CHARCOAL AND PASTEL PENCILS: Charcoal is also available in pencils for detail work. Conté pencils provide a wonderful deep black shade while white charcoal pencils are indispensable for rendering highlights on toned paper for your charcoal drawings. Additionally, you can use pastel pencils in a variety of colors and tones to add tints to your drawings.

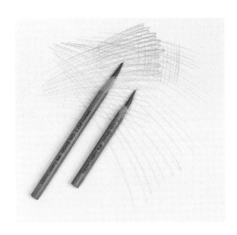

SANGUINE PENCILS: Sanguine pencils bring warmth and softness to drawings, especially portrait sketches, because of their fleshy tint. Although sanguine tints can be acquired in Conté and pastel mediums, this oil-based pencil has a lovely way of holding its line and achieving subtle blending. Use it on cream-colored paper with white charcoal highlights for a very pleasing visual appeal.

CONTÉ AND HARD PASTELS: These square sticks come in a large variety of tints, tones, and shades, including the warm earth and flesh tones shown here. Hard pastel sticks are a degree softer than pastel pencils and considerably firmer than soft pastel sticks. Hard pastels and Conté crayons are excellent sketching tools for emphasizing tonal effects.

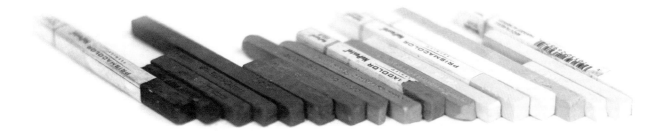

Hard pastels and Conté crayons

SOFT PASTELS: Soft pastels are available in a wide variety of colors, shapes, and lengths. These pastels are prone to richer application and greater smudging, giving them a painterly appearance. They are capable of yielding highly refined realism or loose impressionism. You'll want to gain proficiency and confidence with soft charcoal before moving on to soft pastel.

Soft pastels produce rich color and are well suited for blending and layering.

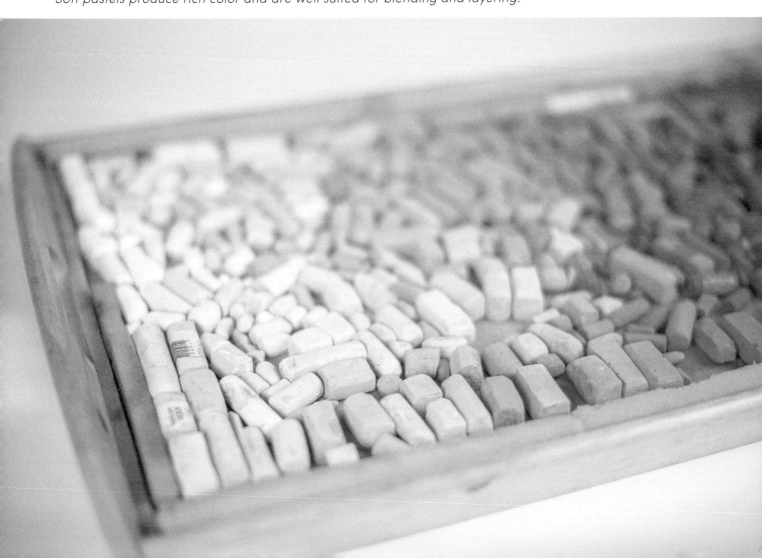

INK PENS: India ink pens are a convenient way to sketch with permanent ink without using a traditional pen-and-ink method. These acid-free ink pens come in a variety of pen nibs to achieve different stroke weights. They are an ideal choice when learning to develop linear techniques.

MARKERS: Markers are excellent tools for ink-based sketching. Some are dual-brush pens with a fine tip on one end and a brush tip on the other. Try ink pens that are water-based, blendable, and acid-free for use in sketching or more finished studies. Simple three-value marker drawings are an excellent way to test out design ideas.

COLORED PENCILS: Colored pencils are wax or oil-based pigments encased in wood. Far less smudgy than pastel and charcoal pencils, they are a great option when you desire a clean color impression while retaining control of the stroke. Colored pencil can be layered and built up to create deeper, richer colors and tones.

SKETCHBOOKS, DRAWING PADS, AND SINGLE-SHEET PAPER: Less expensive drawing pads or sketchbooks are perfect for beginner artists—they accommodate tons of inexpensive drawing practice. If you can afford it, start with a decent-quality white artist's sketchbook or pad. Acid-free, 100-percent-cotton-rag paper is the premium grade, a desirable choice for more finished drawings.

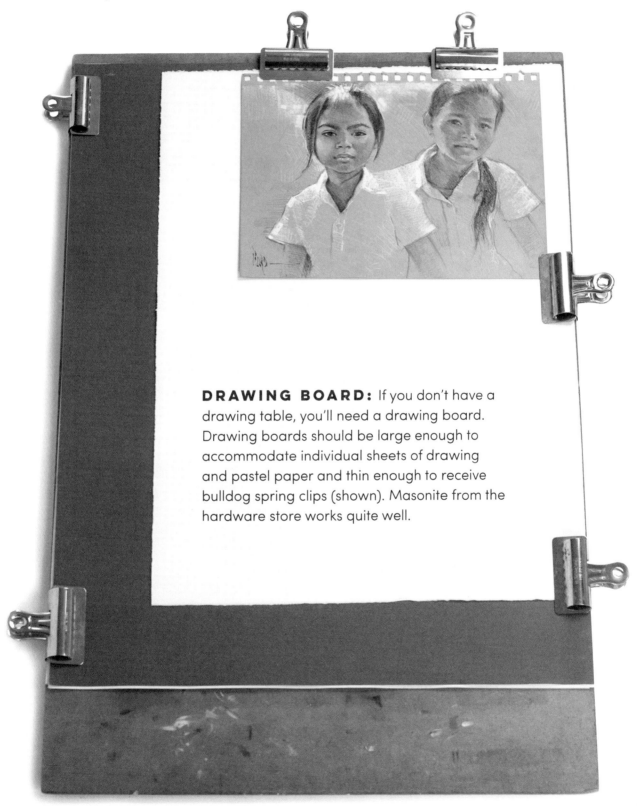

DRAWING BOARD: If you don't have a drawing table, you'll need a drawing board. Drawing boards should be large enough to accommodate individual sheets of drawing and pastel paper and thin enough to receive bulldog spring clips (shown). Masonite from the hardware store works quite well.

BLENDING TOOLS: There are a host of blending tools that can help the artist achieve soft tonal effects, smudging, and diminished lines. Here is a selection of tools I use:

CHAMOIS CLOTH
Chamois is an all-natural skin cloth that is great for blending areas into a soft tone.

PAPER TOWELS
These are excellent tools for rubbing and blending larger areas of graphite and charcoal.

BLENDING STUMPS
Stumps are tightly rolled thick paper used to blend large and small areas of graphite.

TORTILLONS
Tortillons are rolled more loosely than stumps, and are used for blending smaller areas of graphite and charcoal.

PASTEL SHAPERS
These rubber-tipped brushes come in many shapes and profiles.

PASTEL BRUSHES
Pastel brushes are made of short, cropped pony hair.

HAKE BRUSH
This flat, Chinese wash brush works well for soft blending, fusing edges, and brushing out areas.

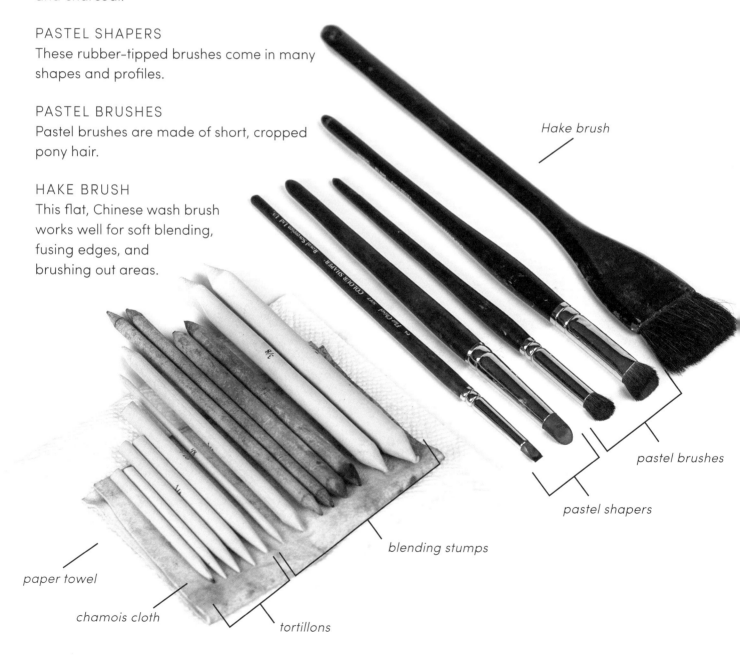

Hake brush

pastel brushes

pastel shapers

blending stumps

paper towel

chamois cloth

tortillons

FIXATIVE: Fixative comes in either a spray bottle or an aerosol can. It can be used to secure layers of a drawing before further work, or to set the final drawing in place. Use aerosol cans in well-ventilated areas. While not necessary for graphite drawings in most cases, fixative is excellent for setting sensitive charcoal or pastel studies.

OTHER TOOLS:

Use artist tape to create clean borders on your drawings or for taping your paper to the backing board. It is low-tack so you can remove it without ripping your drawing paper.

T-squares and rulers of varying lengths help you achieve perfect horizontal lines and 90-degree angles. These tools are important for perspective exercises.

Viewfinders are also helpful for making compositional choices in the field or studio.

A value scale is an excellent visual aid in learning to identify correct values.

Long, straight skewers help you take measurements and find angles.

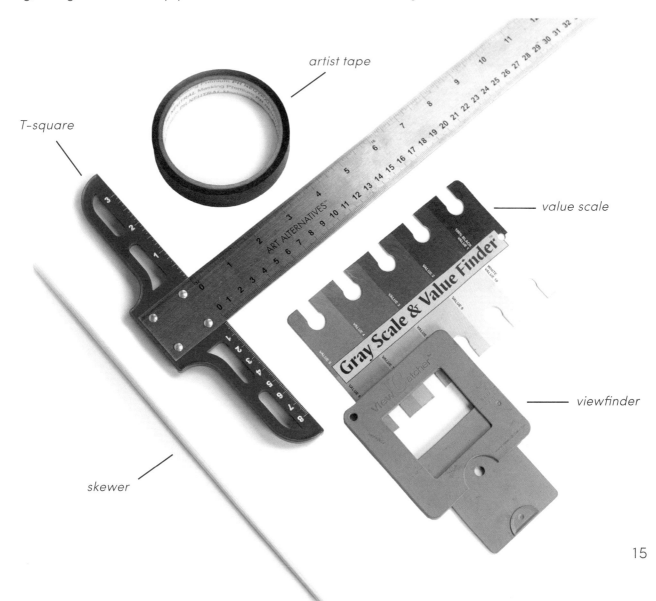

artist tape

T-square

value scale

viewfinder

skewer

GETTING *Started*

Setting Yourself Up for Success

Good drawing begins with the setup. Unhindered observation of both the subject and the working surface and the ability to comfortably render what you see are just as important.

First off, position yourself at the drawing board so you can view both your subject and the working surface comfortably. A quick shift of the eyes is all that should be necessary to make a comparison. I like to stand at the easel while working, placing my drawing board at eye level.

For those who need (or wish) to sit while drawing, use a raised drawing table or a low-positioned easel that, when placed at or close to 90 degrees, enables clear viewing of your working surface and subject.

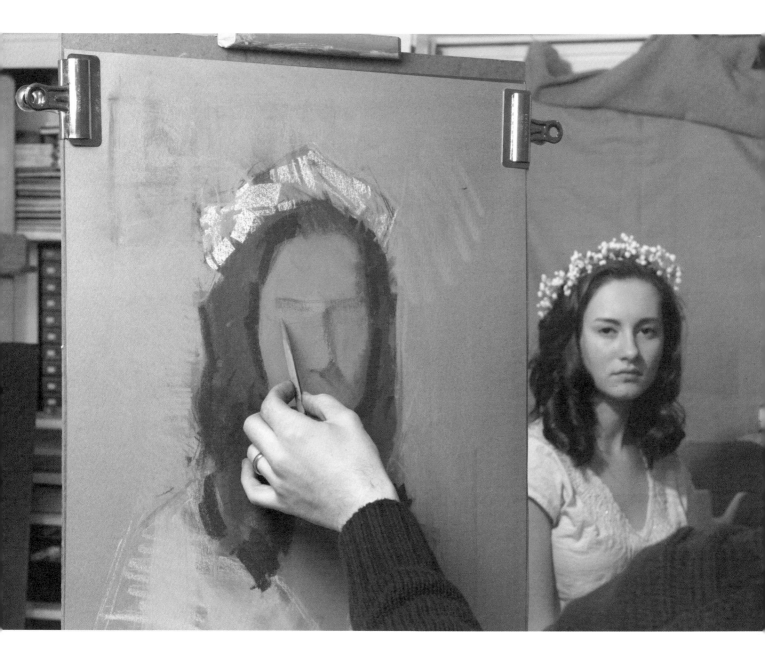

Also stand a full arm's length from your paper. This allows you to create movements that originate from the shoulder instead of the wrist, encouraging a looser and freer mark-making style.

BEWARE OF WORKING TOO CLOSE TO YOUR DRAWING! A CLOSE PROXIMITY CAUSES YOU TO FOCUS ON ONLY A SMALL SECTION OF THE DRAWING, LOSING THE IMPRESSION OF THE WORK AS A WHOLE.

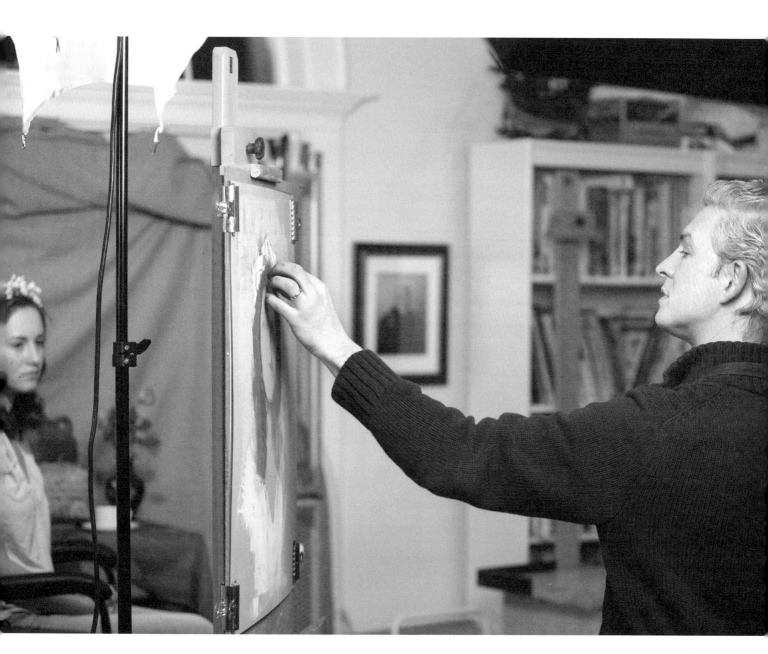

Reference Photographs

When working from reference photographs, use quality, well-exposed images that reveal a clear spectrum of light, middle, and dark tones. I use large 8" x 10" prints whenever possible. Mount them flat on your drawing board at eye level or onto a piece of foam core, placing them just to one side of your working surface.

Use artist tape or clamps to attach your drawing paper securely to the backing board, taking care not to wrinkle the paper.

ELECTRONIC TABLETS HAVE BECOME A POPULAR AND EFFECTIVE WAY TO VIEW PHOTO REFERENCES IN THE DIGITAL AGE.

Holding the Pencil

Now that we've covered your correct positioning at the drawing board, let's talk about the proper use of the pencil. Your arm position and placement of the pencil in your hand are very important. Each alteration in position creates a line or mark of unique character. Take a look at the three basic positions for holding a pencil and the adjustments that are possible with each of them.

Position 1A: Loose underhand (long)

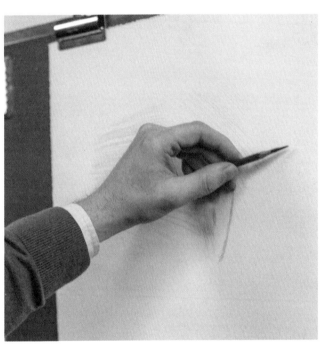

Position 1B: Loose underhand (short)

LOOSE UNDERHAND (LONG AND SHORT): The first position is what I call "loose underhand." This involves lightly pinching the pencil between the thumb and index finger, allowing the stem of the pencil to descend into the palm of the hand. It's an excellent position for loose sketching and massing in tone. Fluid movement of the pencil should originate at the shoulder and involve the elbow.

Position 1A shows a long placement with fingers holding the pencil lower down, creating a more fluid and sketchy mark. Position 1B shows a shorter placement of the pencil, creating a firmer stroke and a bit more control while still involving the shoulder for loose expressive marks. In the overhand position, the palm of the hand is primarily facing the paper or at a right angle to it.

LOOSE UNDERHAND REVERSE: The second position of the hand is really a variation on the first. I call it the "loose underhand reverse." While in position 1, rotate the palm of the hand away from the paper until it is facing you. This is a good position for continued loose sketching on horizontal planes or creating fluid, soft tones. Use a slip-sheet under your hand to prevent smudging the drawing with the back of your hand.

It's quite natural to shift the hand from position 1 to position 2 to achieve a variety of stroke qualities and directions. While loosely sketching, maintain the use of your elbow and wrist to foster fluid movements.

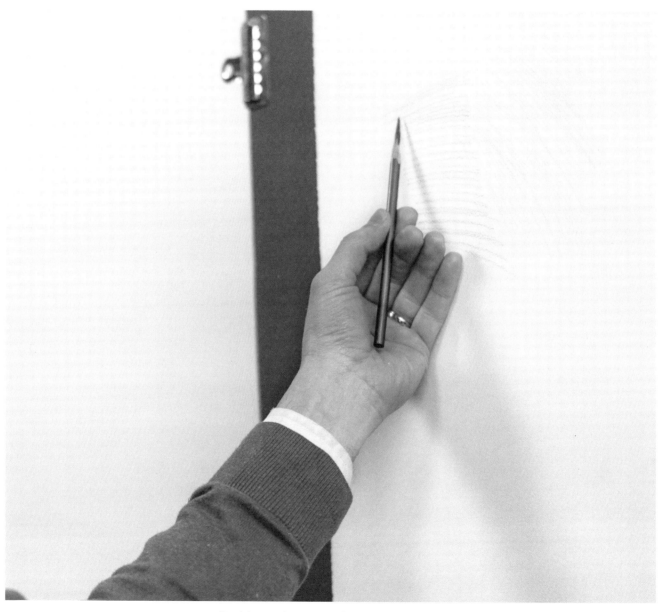

Position 2: Loose underhand (reverse)

WRITING POSITION:

When more control is required, shift the pencil to position 3—the "writing position." Grip the pencil more firmly at four points of contact: the index finger, middle finger, thumb, and inner palm. This position allows for very precise control but limits flexibility and movement. It is a good position for refinement and detail work as well as creating short, choppy marks. Finger movement is emphasized in this position.

Try not to squeeze the pencil—it may cramp your hand after prolonged work. Also, avoid pressing down too hard on the paper and making indents. Pencil length can be shifted in the hand from longer to shorter depending on your preference for greater movement (longer position) or control (shorter position). You may need to use a slip-sheet under your hand to avoid smudging your drawing while using this position.

Position 3A: Writing (long)

Position 3B: Writing (short)

BASIC *Drawing* TECHNIQUES

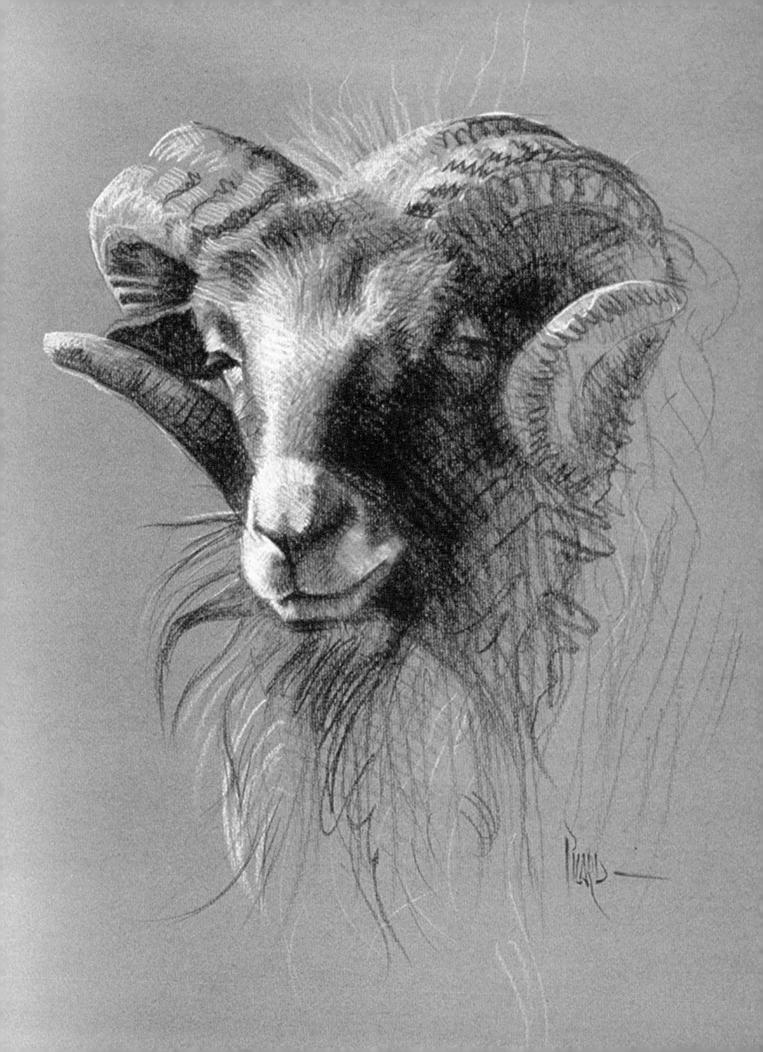

Visual Habits

Drawing is the foundation of all painting, thus great care should be taken to establish good habits. Doing so is a tremendous investment in your artistic development; you'll reap rewards for the remainder of your artistic journey.

The challenge for the visual artist is to consciously cast aside preconceived notions of how a subject *ought* to look and learn to actually *see* it anew with artists' eyes. We do this by learning to study the patterns of light and shadow falling on and around the subject. Here are some visual techniques and approaches to help you see like an artist:

SQUINTING

Squinting at the subject simplifies the subject to very simple masses (or shapes) of light and dark.

SEEING EDGES

Edges are found at the intersection of contrasting values and define the separation of major shapes of value. Evaluate whether edges are hard (sharp), soft (blurred), or broken (textured).

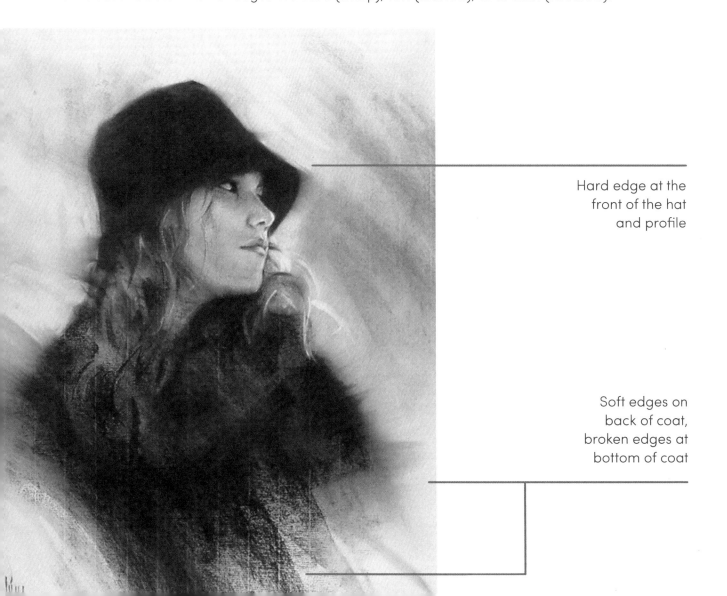

Hard edge at the front of the hat and profile

Soft edges on back of coat, broken edges at bottom of coat

Use a mannequin's head size as a vertical unit to understand the height of the drawing. For example, there are 6.75 head units running from top to bottom.

UNITS OF MEASUREMENT

To scale your drawing and establish proportions in correct relationship to one another, select a clear and easy portion of the subject to use as a unit of measurement for reference against other parts of the scene.

For example, when drawing a person, use the vertical height of the head as a unit of measurement to check the length of the whole body from top to bottom. How many head lengths will fit into the whole figure? This will control your proportions very effectively.

ANGLES AND MEASUREMENTS

Another tool for simplifying complicated forms is what I like to call "angularizing." It's a way of reducing the subject's subtle curves into a simpler, more manageable shape by grouping smaller details into large, simple shapes made up of a few straight lines.

Check angles and angle changes on your subject by holding your pencil—or a long skewer stick—out between you and the subject on your line of sight. (Closing one eye can help to simplify your line of sight when checking angles.) Always be sure to draw the big angles first before dealing with little ones!

LEVEL AND PLUMB

When trying to locate the major landmarks and angle changes of the drawing, plumb and level lines are indispensable visual tools. Plumb refers to perfectly vertical, and level refers to perfectly horizontal. Use plumb and level lines to view and dissect your scene. Hold up your pencil or skewer within your line of sight to check the subject for these angles. (Close one eye to simplify your view if needed.) Once you find these lines within your subject, check all the other angles against them.

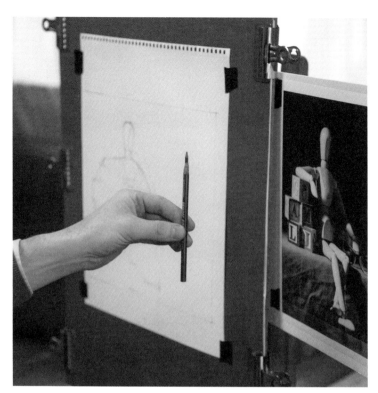

Hold the pencil vertically to check locations right and left of the plumb line.

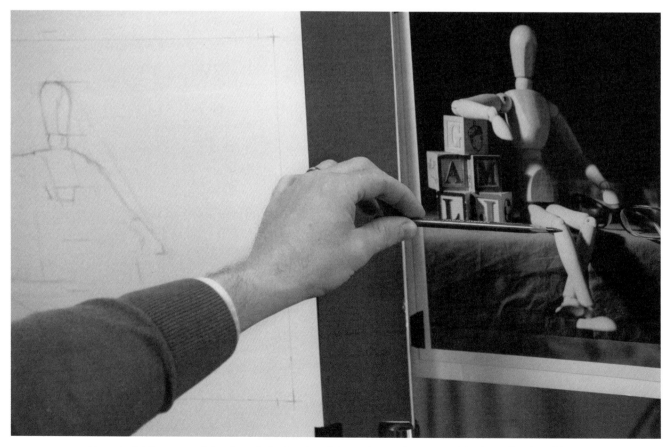

Now hold the pencil horizontally to check locations above and below the level line.

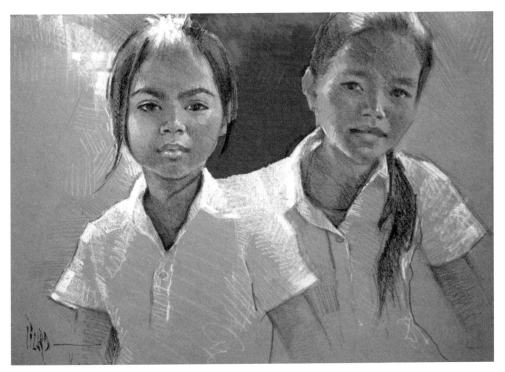

NEGATIVE SHAPES

Our minds tend to focus on the "positive" shapes that we are looking at, such as the flower, person, or tree we're drawing. Instead, try looking for the simple negative shapes that fit in and around your subject. This is an excellent way to check your drawing from a different point of view.

Notice the negative shape between the two heads, toned darker for emphasis.

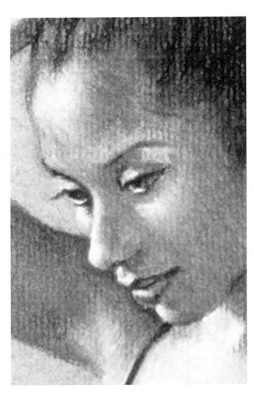

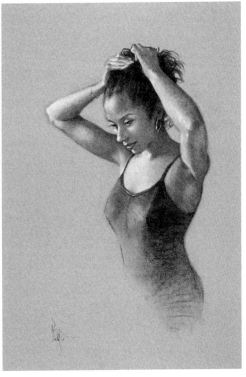

STEPPING BACK

Stepping back from your work often to view it from a distance is an essential, and often forgotten, visual habit. Mistakes are so much easier to see from a few feet away as the big impression of the work comes into perspective, rather than when you're right on top of your drawing. Step back often to see the bigger picture! You'll be glad you did.

Detailed view of the subject when working up close

The whole subject viewed from a distance by stepping back

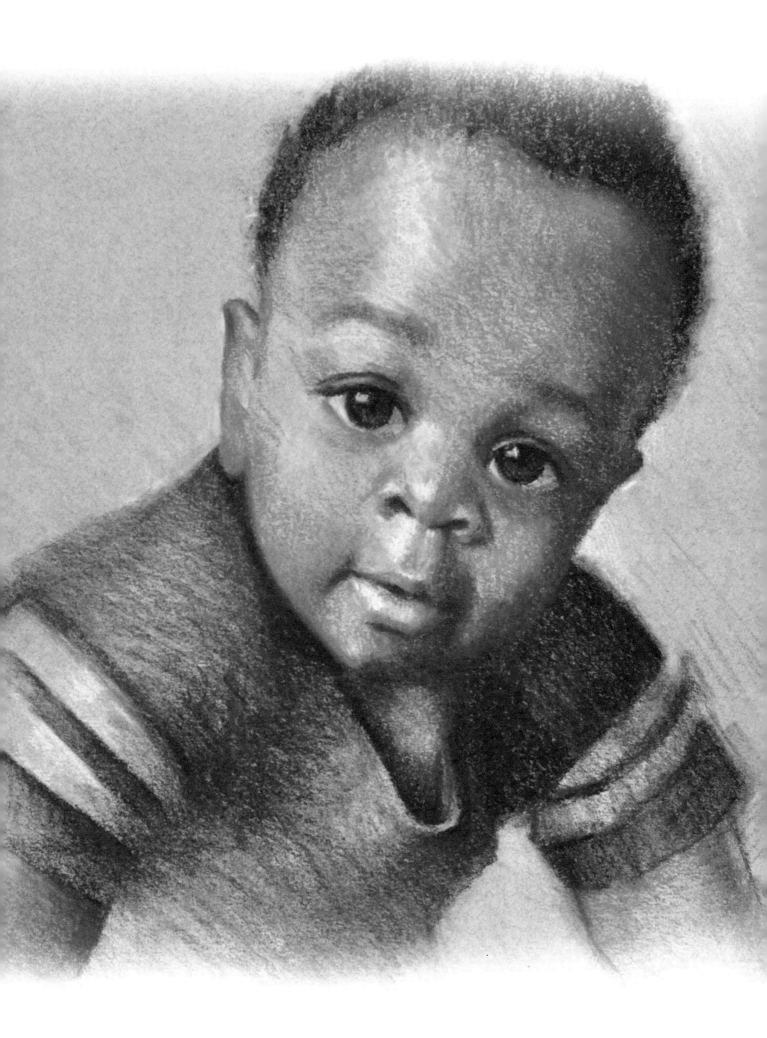

Drawing Habits

Just as the alphabet is made up of many unique characters, there are several types of lines to learn and explore, and a variety of ways to convey tone and texture. We'll practice these methods as we discover them.

Your goal should be to develop, master, and employ all the tools available for communicating visually. Repeated practice and mastery of the following mark-making techniques will empower your hand with skill and lead toward the authentic development of your own individual style.

RELAX! DON'T WORRY ABOUT YOUR ARTISTIC "VOICE" AT THIS STAGE OF DEVELOPMENT. IT WILL COME NATURALLY AS YOU SPEND LOTS OF TIME PRACTICING AND EXPERIMENTING WITH NEW TECHNIQUES.

TYPES OF LINES

FAST LINES: Excellent for conveying energy and movement, fast lines give the look of a loose, sketchy approach.

PRACTICE MAKING FAST LINES; SKETCH IN A DIRECTIONAL MANNER TO GIVE THE FEELING OF MOVEMENT. DON'T WORRY ABOUT THE RESULT, JUST GET USED TO MOVING FAST WITH THE PENCIL!

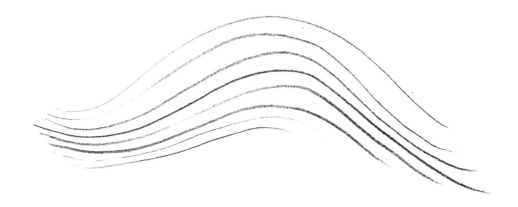

SLOW LINES: When more control is desired, use slower lines.

Practice making lines slowly, moving smoothly with the pencil to make more controlled curvilinear lines.

BOLD LINES: Perfect for punctuating your statement with contrast and confidence, bold lines convey strength and solidity.

Use a thick dark pencil, charcoal, or a broad-tipped ink pen to practice drawing bold lines.

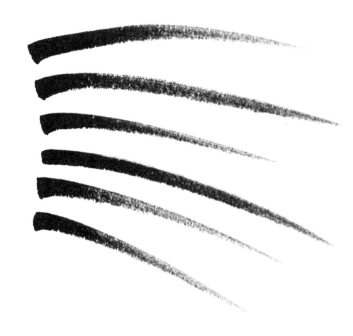

SENSITIVE LINES: Right beside those bold lines, practice making some delicate, sensitive lines to reveal the impact of contrasting weights.

LONG LINES: Practice carrying the pencil across the page for an extended period of time to suggest fluid movement and flow with long lines.

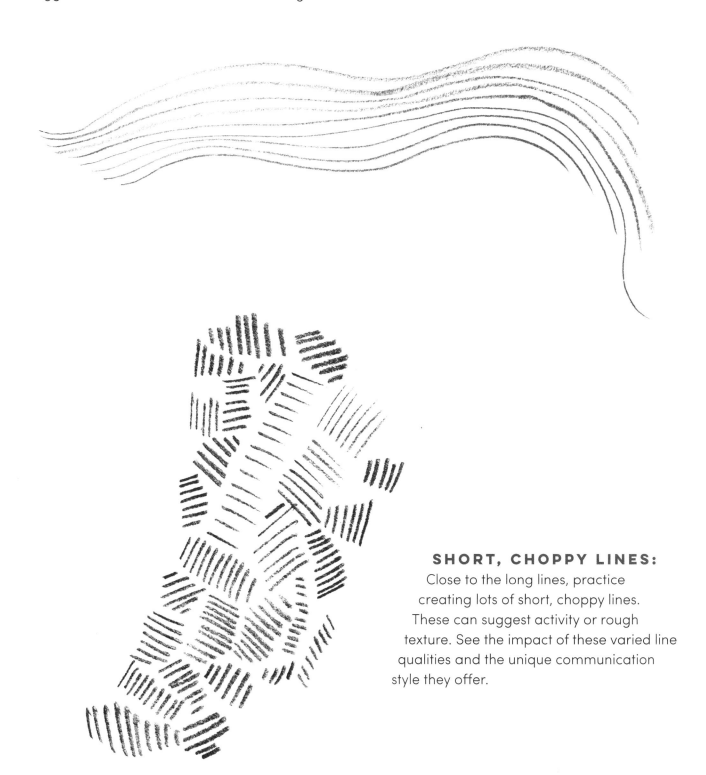

SHORT, CHOPPY LINES: Close to the long lines, practice creating lots of short, choppy lines. These can suggest activity or rough texture. See the impact of these varied line qualities and the unique communication style they offer.

SCRIBBLED LINES: Erratic, squiggly, continuous lines are great for conveying texture, motion, and a general shape without detail.

Practice scribbled lines until you build up a textured area.

THICK MARKS: When conveying a mass of tone in an area and emphasizing the value of the shape, thick sidestrokes of graphite, charcoal, or Conté work very well.

Practice dragging your pencil on its side to create soft, tonal marks.

Combine these tonal marks with linear strokes to produce wonderful results.

CONTOUR DRAWING

Contour drawing is an excellent way to train your eye to see and your hand to record the essential elements of the subject with line. Focus on observing the outside shape, or contour, of the subject in front of you (or in a photograph).

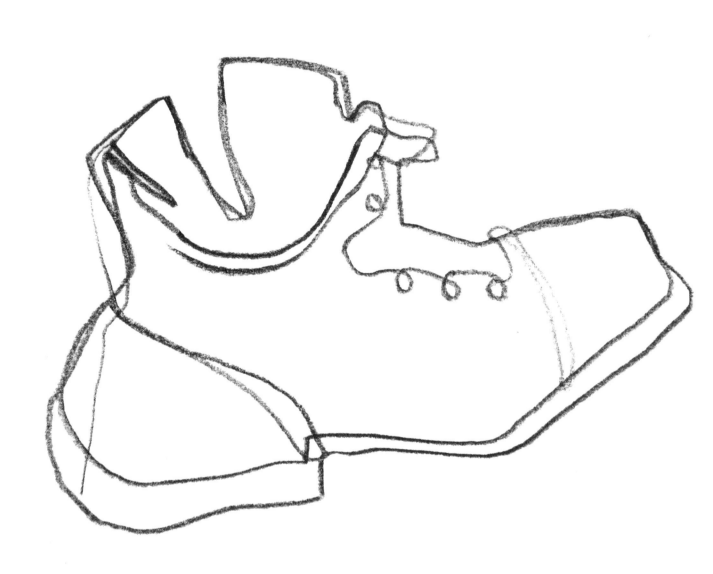

PRACTICE: BLIND CONTOUR

Draw an object, such as a shoe or your hand, using a continuous line. Pick a starting point and don't look at your paper until you're finished. You'll be surprised how well you can capture the object!

PRACTICE:

Now try drawing clouds using contour lines, occasionally looking at your paper.

GESTURE DRAWING

Whereas contour drawing describes the outside shape of the subject, gesture drawing focuses on capturing the *movement* of the form or figure and conveying action. This drawing approach trains your eye to see and quickly establish movement and trains your hand to record it quickly.

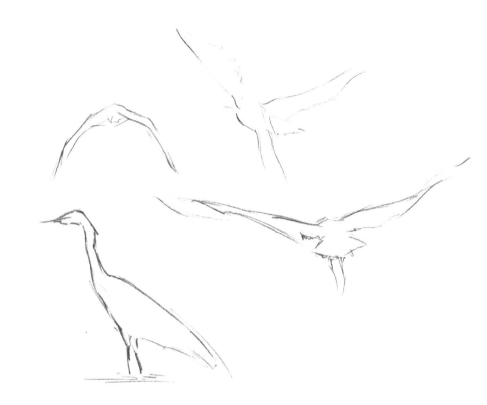

PRACTICE:

Draw a fast sketch of birds flying.

PRACTICE:

Draw a fast sketch of a person running.

HATCHING AND CROSSHATCHING

Suggest tone by creating quick repetitive lines moving in the same direction; this technique is called "hatching." When you need to suggest greater depth and build up more form on your subject, change the direction of your lines and cross over the previous layers. This crisscross method of building up linear strokes is called "crosshatching."

PRACTICE:

Draw tone on clouds using hatching.

PRACTICE:

Draw tone on clouds using crosshatching.

DRAWING EDGES AND PATTERNS

It's time to build on our understanding of edges from the "visual habits" section by practicing locating the main edges of a scene. Patterns build on the concept of edges because each pattern represents a different texture of a surface—such as rough or smooth, round or flat. Where different patterns meet, an edge forms. Utilize a variety of the mark-making techniques to describe the texture and design of patterns.

PRACTICE EDGES:

Draw a landscape with six lines.

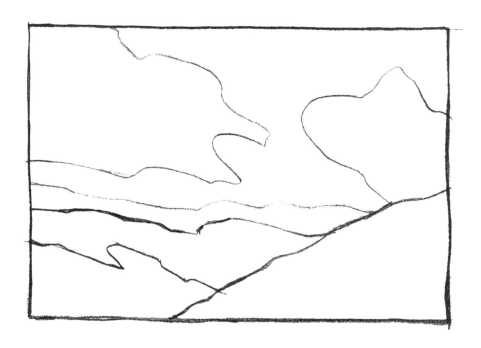

PRACTICE PATTERNS:

Draw two patterns overlapping (smooth and rough).

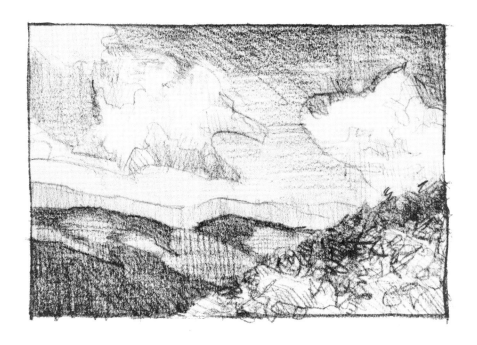

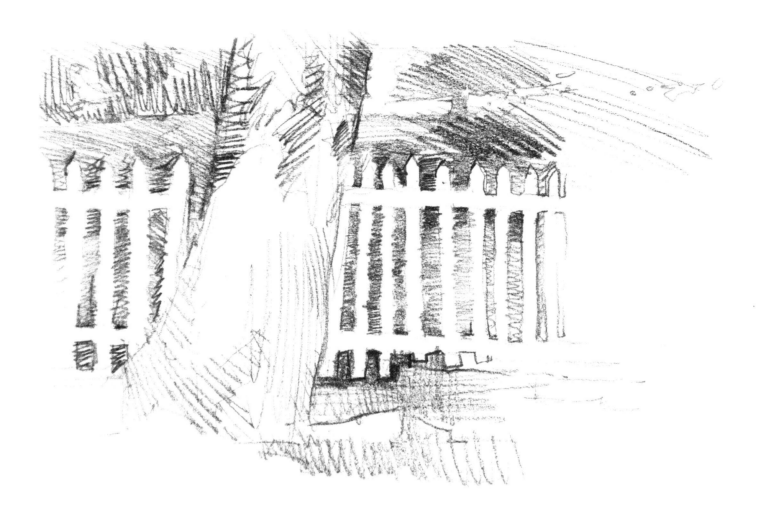

NEGATIVE SPACE DRAWING

When it is difficult to draw the subject, try drawing the area that surrounds the subject—the negative space—instead. To practice seeing negative shapes, use hatching and/or thick sidestrokes to mass in the negative space. This technique is especially effective when a dark background surrounds light objects.

PRACTICE: Draw tone on negative shapes around a white fence.

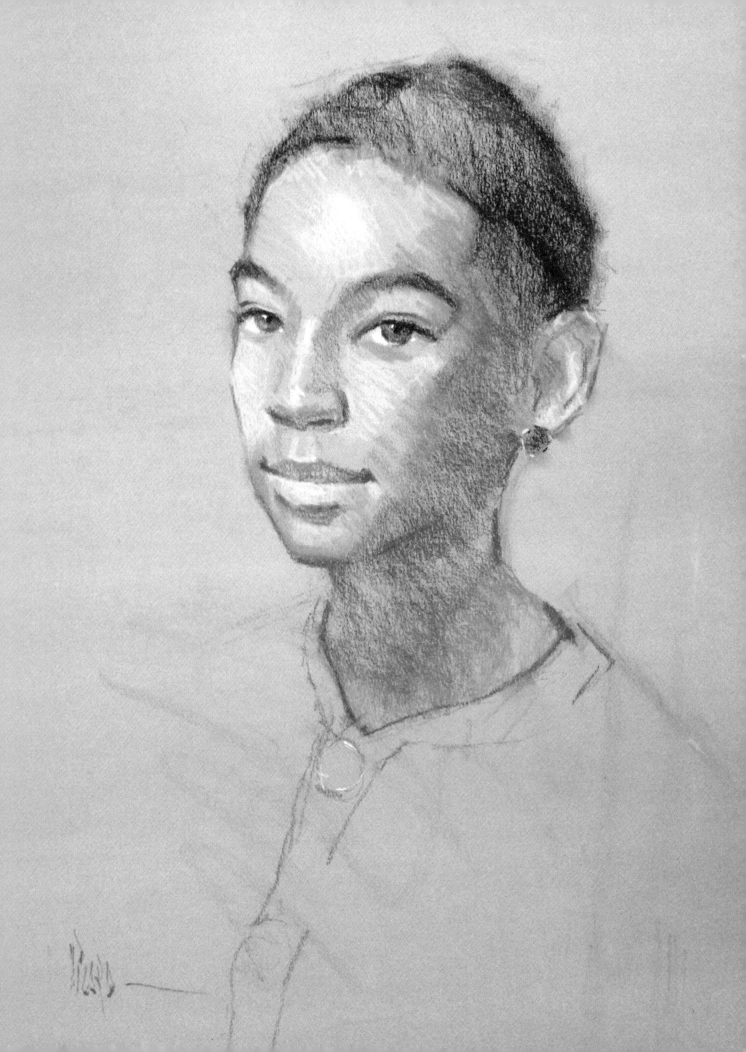

Routine Habits

They say it takes 10,000 hours to master any given skill, so if we want to learn to draw, we've got to start logging those hours! Routine habits are all about embedding these repeatable practices into your drawing approach and developing the discipline of regular working habits. The outcome of this disciplined approach is artistic confidence and repeatable success. On page 127, find out how to develop your working routine.

WARMING UP: Start out loosely. Use the loose underhand position at this stage. (See positions 1 and 2 on pages 21–22.) Warm up your hand and engage your visual perception with a few warm-up sketches.

ROUGHING IN THE DRAWING: Keep it light as you first search out the main shapes. Use your whole arm, continuing to employ drawing positions 1 and 2 for a loose approach. Don't dig in with your pencil by pushing too hard—keep it loose and sketchy! Focus on the gesture and contour and the division of light and shadow.

DEVELOPING THE DRAWING: Develop with tone. Use the softer pencils such as 4B, 6B, and 8B for deeper darks, and begin to apply greater pressure with the pencil. Develop edges, tones, and textures using your drawing techniques.

REFINING THE DRAWING: Shift to position 3 (see "Writing Position" on page 23) for fine detail development. Sharpen edges and soften tone where needed. Develop patterns, texture, and overall subtle tonality without losing the strength of the big shapes. Darken the darks, add highlights, and clean up any unwanted lines and smudges with an eraser. Review the work from a distance often to make final decisions.

DELIBERATE PRACTICE DEVELOPS SKILL THROUGH CONSISTENCY AND REPETITION.

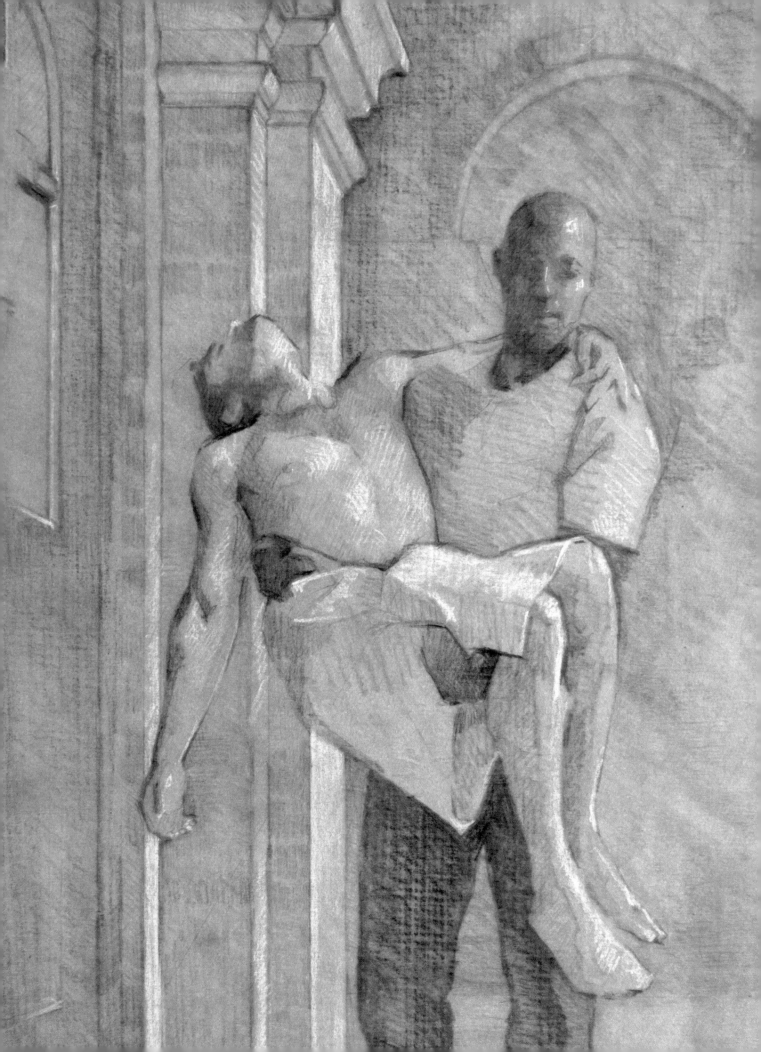

The Illusion of Space: Perspective Basics

Drawing a realistic scene requires learning how to communicate a sense of space or depth. We must trick the viewer's eye into believing that a two-dimensional paper is a window into a three-dimensional space.

Now, there's no need to make our drawings look overly precise or geometric, but we do want them to look realistic. Understanding the rules of perspective gives us greater freedom to create the illusion of space on paper.

THE ILLUSION OF SPACE REQUIRES A BASIC UNDERSTANDING OF THE LAWS OF LINEAR AND ATMOSPHERIC PERSPECTIVE.

FUNDAMENTALS OF PERSPECTIVE

First, let's address the concept of linear perspective. Here are some fundamental terms and rules that are important to learn (from Joseph D'Amelio's *Perspective Drawing Handbook*).

Diminution:
Objects will appear smaller, or diminish in size, as their distance from the viewer increases.

Convergence:
Lines or edges of objects, which are in reality parallel to each other, will appear to come together, or converge, as they recede from the viewer.

Vanishing point: Any two or more lines that are in reality parallel will appear to come together—or converge—and meet at a vanishing point. Objects located at ground level find their vanishing point on the horizon line.

Line of sight: This refers to the fixed position of the viewer's field of vision, enabling a perspective drawing. There are an infinite number of directions a line of sight can take by merely moving your eyes or turning your head slightly, but to draw a scene in perspective, we must limit this direction to just one line of sight. The line of sight creates an "eye level" view of the scene.

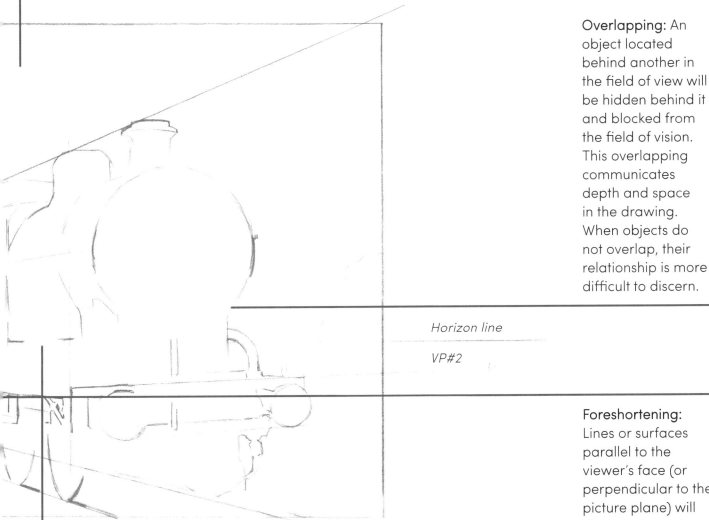

Horizon line

VP#2

Overlapping: An object located behind another in the field of view will be hidden behind it and blocked from the field of vision. This overlapping communicates depth and space in the drawing. When objects do not overlap, their relationship is more difficult to discern.

Foreshortening: Lines or surfaces parallel to the viewer's face (or perpendicular to the picture plane) will show their maximum size. As they rotate away from the viewer, they appear increasingly shorter.

Horizon line: This is a horizontal line that describes the separation between sky and land from the viewer's eye level. Looking straight ahead at the scene (as I did for this sketch) creates the most common and relatable eye-level experience to our usual field of view, and the horizon line is in the middle of the scene.

ONE-POINT PERSPECTIVE

Let's begin our application of these laws of perspective in the simplest of conditions: the one-point perspective.

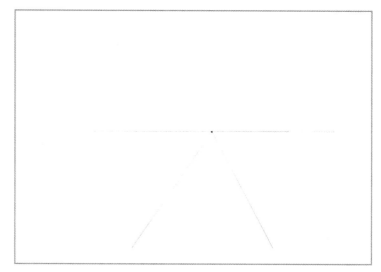

Draw a horizon line in the center of your paper, and then place a single mark in the middle of the horizon to indicate the vanishing point. Now use a straight edge to draw lines coming toward the viewer from the vanishing point.

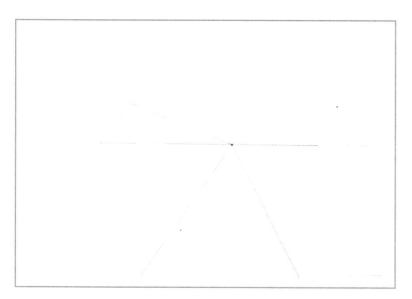

These lines create a road that fades off into the distance, revealing the principles of foreshortening and convergence. Add another line going up and to the left from your vanishing point to indicate the top edge of any repeating objects, such as trees, buildings or, in this case, some telephone poles.

Add vertical lines that diminish in size and distance from one another as they recede in space.

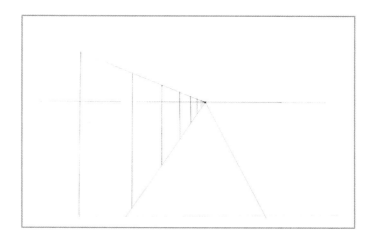

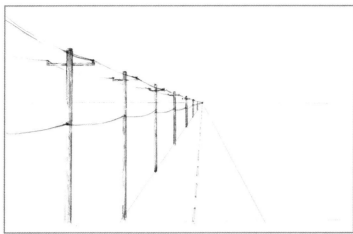

PRACTICE: DRAW A ROAD IN ONE-POINT PERSPECTIVE.

Because there is only one vanishing point in our line of sight, all vertical lines in the scene remain parallel. Add details of the power lines and cross bars to finish the poles.

Here is the view from above the road, with a narrow opening of road at the bottom.

This is the same scene viewed from a lower line of sight. The horizon line drops low in the scene, and the road opens wider at the bottom, as if we are driving on the road.

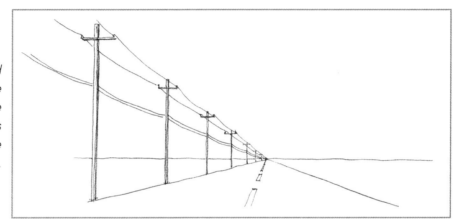

Telephone poles are an excellent example of the principle of diminution because they become smaller as they near the horizon.

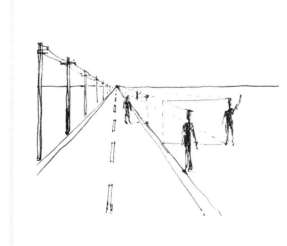

Bonus Tip

When placing figures in your scene, control the scale in proportion to the vanishing point by using the foreground figure as a reference for scale. Draw lines of convergence to the vanishing point from the top and bottom of the figure. Then match the scale of these two lines when placing other figures in varying locations in the scene.

If the figures are off to the left or right, create parallel horizontal lines that extend out from the vanishing point lines to the location of the figure to give you the correct scale.

CUBE IN ONE-POINT PERSPECTIVE

Now let's look at a simple cube in one-point perspective. Notice how the horizontal and vertical lines of the cube, which are parallel to the viewer, do not converge or foreshorten in one-point perspective, while the lines of the cube that are perpendicular to the viewer diminish and converge toward the vanishing point. Even without shading, this gives the cube a strong sense of scale.

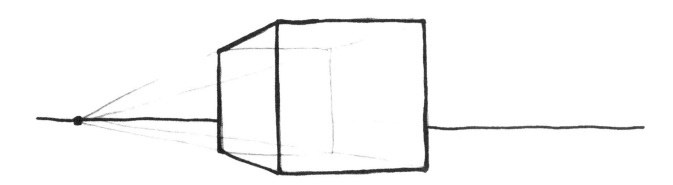

PRACTICE: DRAW A CUBE IN ONE-POINT PERSPECTIVE.

As we move the location of the cube from right to center to left, the converging parallel lines will always follow the vanishing point.

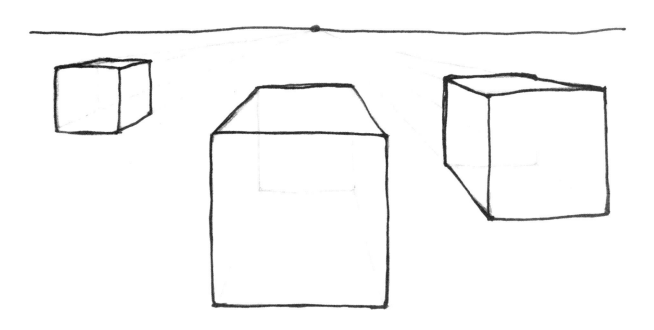

Practice drawing lots of cubes from a variety of angles and vanishing points. Don't feel that you need to use a straight-edge and be overly precise.

First off, draw a horizon line. Then place a vanishing point on it off to one side. Next draw a square with straight horizontal and vertical lines. Simply follow the corners of the square back to the vanishing point in pencil. Close in the back of the cube by drawing a vertical line between converging lines. Close in the top of the cube by drawing a horizontal line between the converging lines. When you are finished with all the sides, use a marker or dark pencil to emphasize the outside lines of the cube.

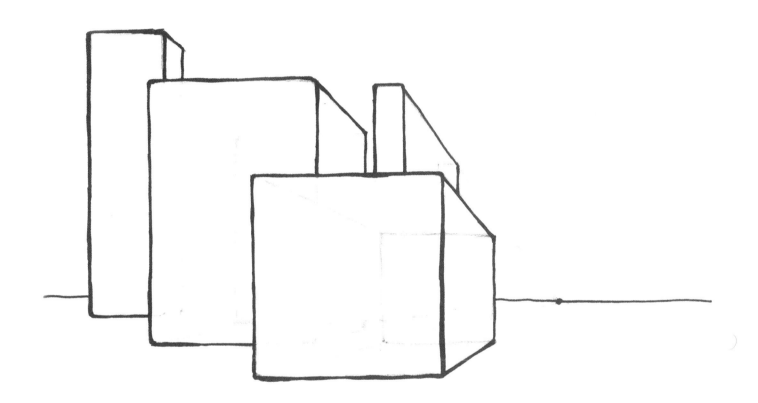

Let's take our study of the cube one step further and apply it to the principle of overlapping. Look at the dynamic impact that overlapping various cuboid (rectangular cube) shapes can have in creating a feeling of depth and space. Extending the vertical shapes at different heights gives an impression of scale, much like a city skyline.

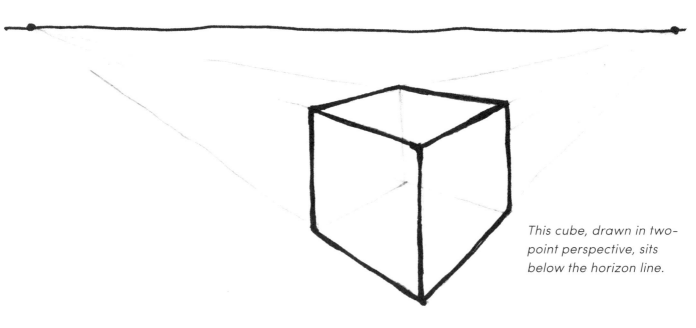

This cube, drawn in two-point perspective, sits below the horizon line.

TWO-POINT PERSPECTIVE

Let's add an additional vanishing point to our horizon line and discover the effect that two points of convergence have on the cube. We see that the vertical lines remain perpendicular to the picture plane (or parallel to the viewer's face) and do not converge. All other edges of the cube converge toward the two influencing vanishing points.

Follow the pencil lines from the front edge of the cube back to the vanishing points to understand how each side converges toward a point on the horizon. The resulting cube, which is viewed at an angle below the horizon line, conveys a realistic impression of space to the viewer.

**PRACTICE: DRAW A CUBOID
(OR RECTANGULAR CUBE)
IN TWO-POINT PERSPECTIVE.**

Try adding a roof to your cuboid, turning it into a barn. Keep your vanishing points far enough away from each other to prevent the structure from becoming distorted with acute corner angles.

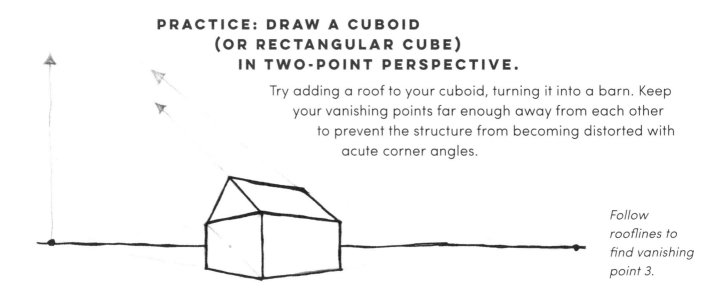

Follow rooflines to find vanishing point 3.

Once you establish your cube, draw diagonal lines between the corners of its front side to reveal the midpoint. Then draw a vertical line through the midpoint of the front square and extend it upward to locate the center roofline. Select your desired pitch for the roof and connect the top corners of the cube to the roofline. Follow the roofline from the front peak back to vanishing point 2 to diminish it in perspective. Now extend the front roofline beyond the roof all the way up to a point directly above your first vanishing point (VP 1). This creates a third vanishing point for your roof edges, and will provide you with the angle of the back edge of your roof in correct perspective.

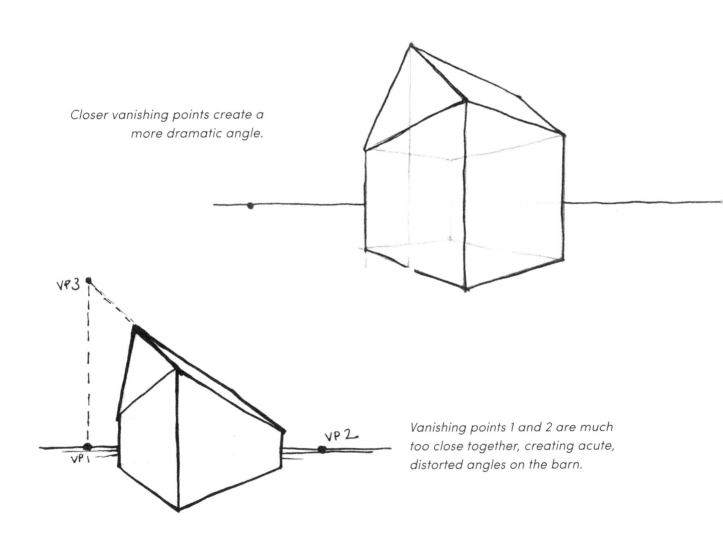

Closer vanishing points create a more dramatic angle.

Vanishing points 1 and 2 are much too close together, creating acute, distorted angles on the barn.

DRAWING IN THREE DIMENSIONS

While the foreground elements of the steam engine are crisp and strong, there is less contrast in the background.

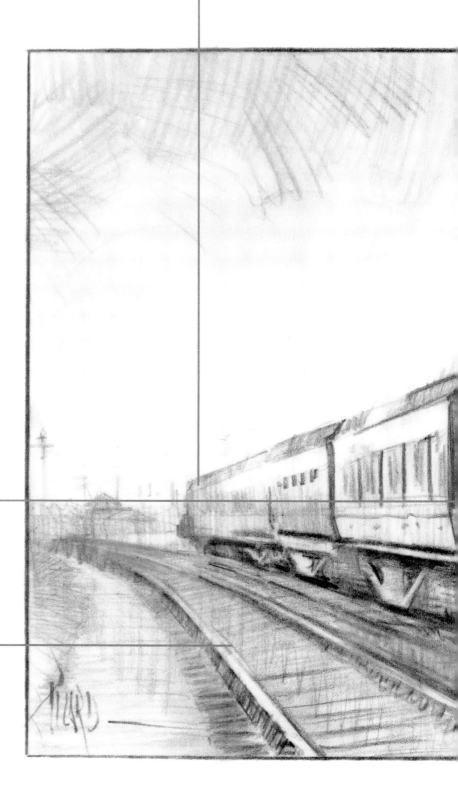

Hatching strokes in different directions convey the plane of the surface.

Lines of convergence from the vanishing point up toward the front right of the image establish the train tracks and the top edge of the train.

Develop more specific outlines of the engine, carts, and wheels to bring the steam train locomotive into focus.

A rectangle at the foreground right of the scene between the tracks establishes the frontal plane of the train.

Power lines that follow the vanishing point lend to further realism.

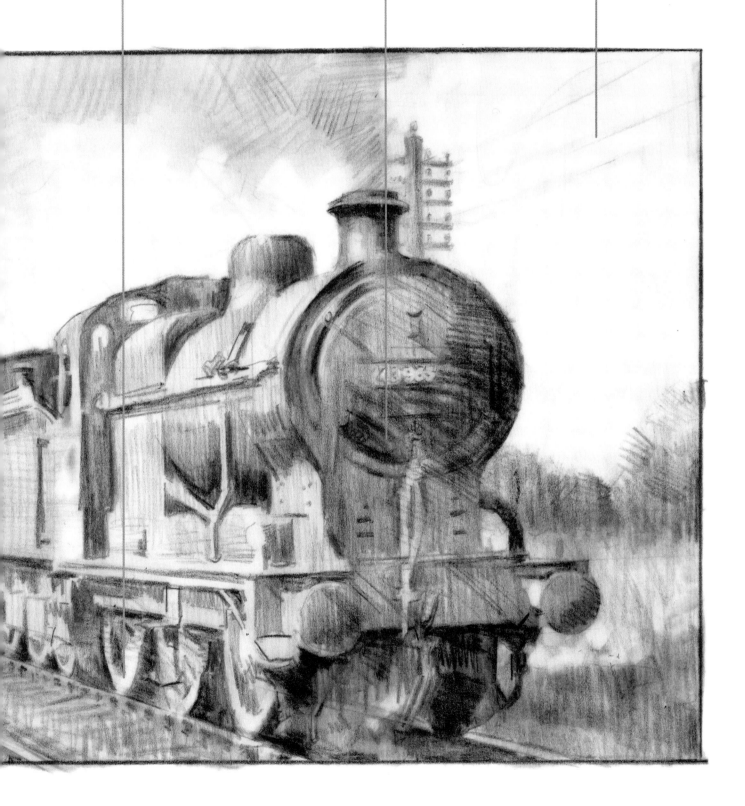

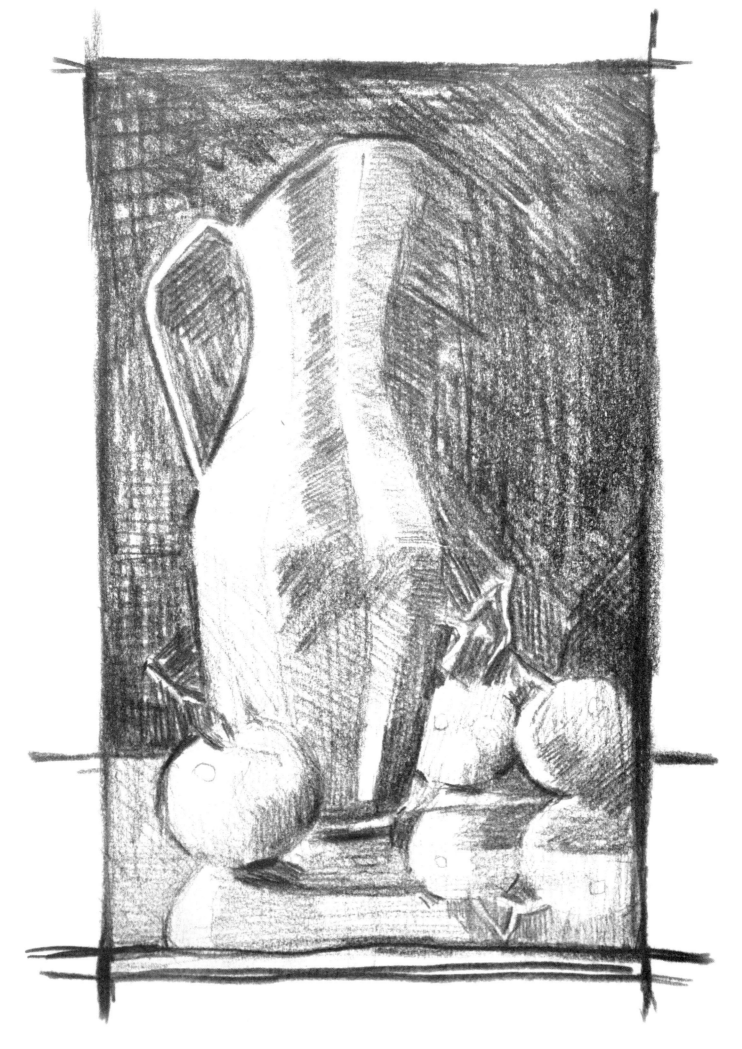

Shape & Volume: Basic Shapes

Virtually everything in the natural world can be simplified or grouped into essentially four basic 2D shapes: the square, triangle, circle, and rectangle. All other shapes can be constructed using these.

Things get really interesting when we add a third dimension to these shapes, thus creating the illusion of form in our drawings. A circle transforms into a sphere or cylinder. A triangle morphs into a cone. A square becomes a cube and can be stretched into a variety of cuboid shapes.

2D SHAPES

Flat 2D shapes exist on a single plane and do not give the impression of space.

PRACTICE:

Draw the four basic shapes: square, triangle, circle, and rectangle.

3D SHAPES

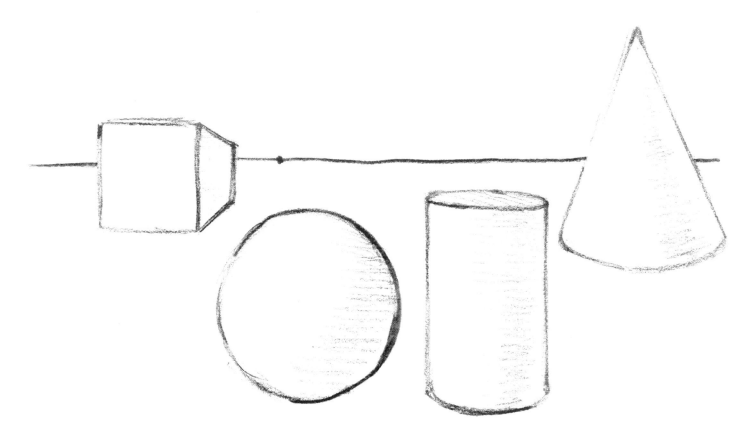

The four basic 3D shapes are roughly placed in one-point perspective on the horizon line. Without the use of overlapping, it is more difficult to understand spatial relationships. Even so, forms appear solid.

PRACTICE:

Draw the four basic shapes—cube, sphere, cylinder, cone. These 3D shapes give depth and dimension (or form) to your objects. Notice the hatching on the edge of circular forms conveys an impression of roundness, like on the sphere, cylinder, and cone.

With our newfound understanding of 3D shapes, let's go for a stroll around the house and discover how these basic shapes can be found in everyday life. Try sketching them loosely and quickly, identifying the big shape first, then adding some quick details.

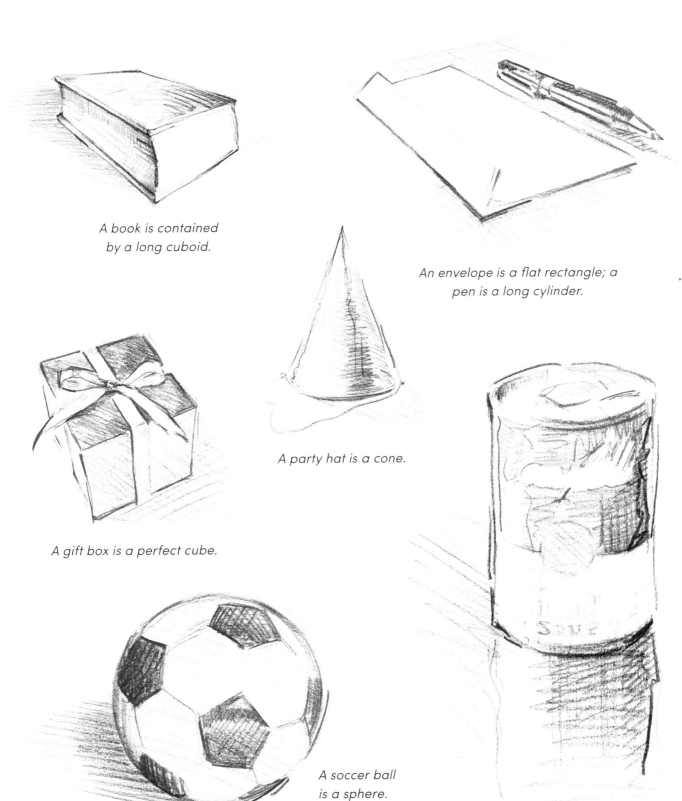

A book is contained
by a long cuboid.

An envelope is a flat rectangle; a
pen is a long cylinder.

A party hat is a cone.

A gift box is a perfect cube.

A soccer ball
is a sphere.

A soup can is a cylinder.

COMBINING 3D SHAPES

Now that we've learned to draw three-dimensional shapes and to anchor them in space using the laws of perspective, let's do an exercise to bring it all together. Sketching in the shapes loosely, allow yourself to draw through the objects as you arrange them together on the surface. What a strong visual impact this cluster of shapes has in communicating solid form, depth, and a sense of space.

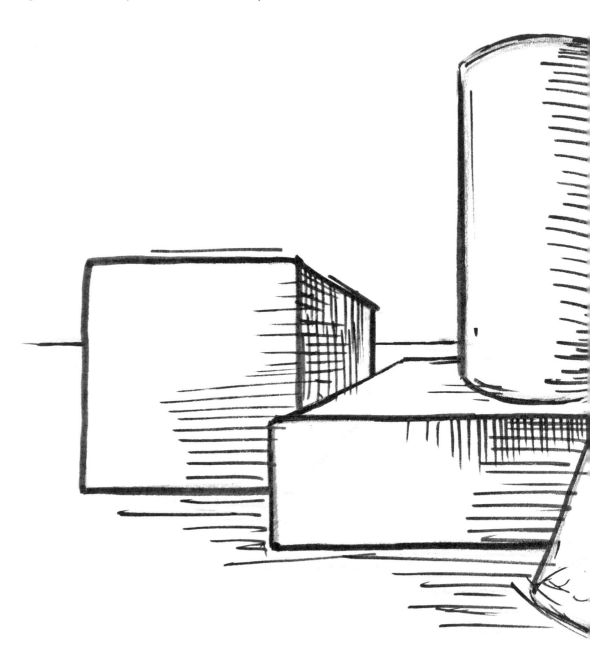

PRACTICE: Draw the basic 3D shapes overlapping each other.

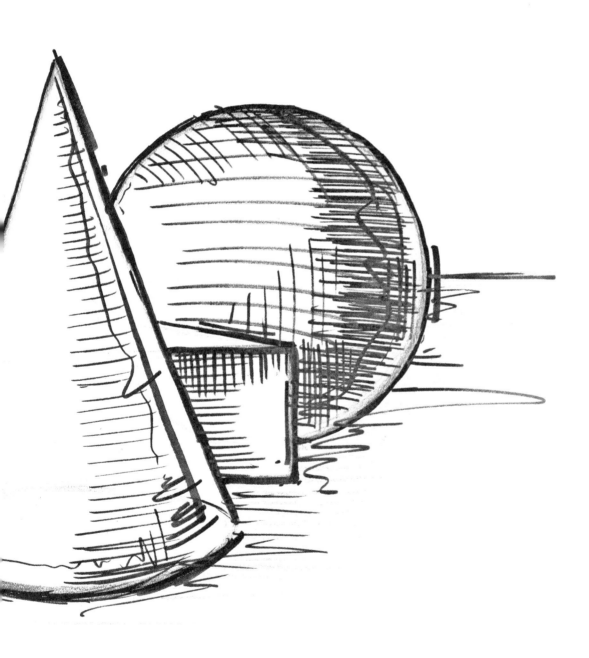

UNDERSTANDING ELLIPSES

When a circle is viewed at an angle, it creates an ellipse. An ellipse is a foreshortened circle. See how a circle placed flat on the ground in one-point perspective creates an ellipse. A vanishing point is used to establish the plane for the ellipse.

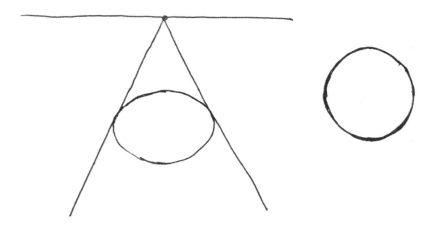

Ensure that the curves of the ellipse follow the actual midpoint of the circle, or they won't be convincing. These curves can be checked by creating a box around the circle in perspective, and drawing diagonal lines from the corners of the box to find the midpoint.

A coin flipped in the air creates a variety of ellipses as it moves. It's a perfect circle when viewed straight on, but we see the changing ellipses as the coin rotates.

When viewing a cylinder from this angle, the top appears elliptical.

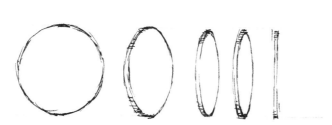

A rotating coin creates various ellipse shapes.

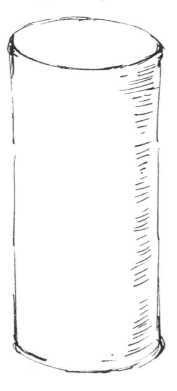

DRAWING WITH ELLIPSES

Tone communicates the light on the side of this round peony.

Notice the variety of strokes and edges, from hard to soft and broken.

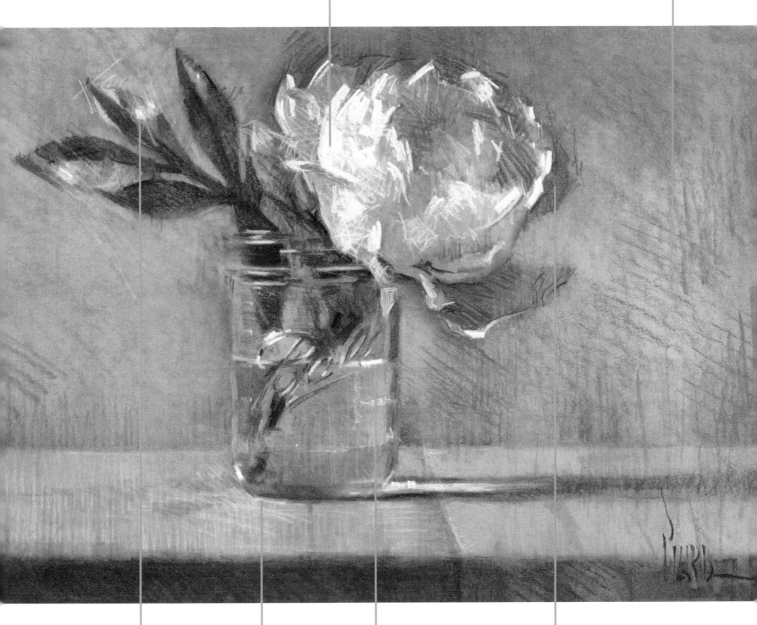

Highlights are developed with a white charcoal pencil and a white Conté stick.

Note the ellipses at the top and bottom of the cylindrical jar.

Pull out highlights in the jar, table, and background using a kneaded eraser.

Build atmosphere with edges and tones, blended with blending stumps, brushes, and a paper towel.

Seeing Tones

Building on our understanding of the illusion of space, let's consider how tone influences depth perception. In the "Visual Habits" section on page 26, we introduced a few key concepts regarding how the artist sees tone. We use visual habits like squinting to identify simple values and discern the edges where values change. This is so important because the artist is only able to describe a very limited amount of the myriad values seen in nature.

REMEMBER TO SQUINT AT YOUR SUBJECTS TO SIMPLIFY VALUES!

SIMPLIFY THE VALUES

A commonly accepted scale of visible tones in a drawing is the nine-value scale plus white. We must practice making these tonal keys communicate tone. To successfully portray the natural world around us, we must be able to simplify values by taking the various colors and shades and reducing them into a very limited amount of values in our drawing. This is a critical skill for the artist to develop. Try making a simple three-value tonal key with a clear separation between the tones.

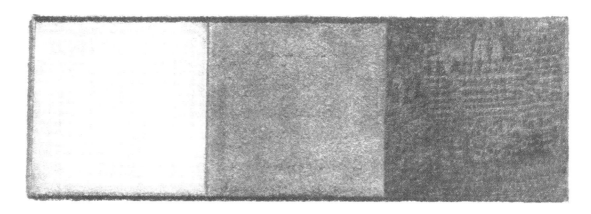

A tonal key

PRACTICE: Draw a tonal key in three values: light, middle, and dark.

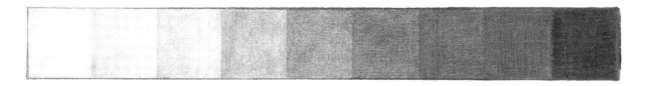

A nine-value tonal key

PRACTICE: Now add greater complexity by drawing the full value range of nine tones plus white. (White is seen outside of the nine-tone scale.)

BLENDING

Subtle blending conveys soft and diffused edges and atmosphere in our drawings. Blending stumps and tortillons soften and subdue pencil marks. A chamois and even a paper towel can be used to blend the pencil or charcoal on the paper. Once you get good at blending, draw your own graded tonal range from light to dark with a very soft gradation between the values.

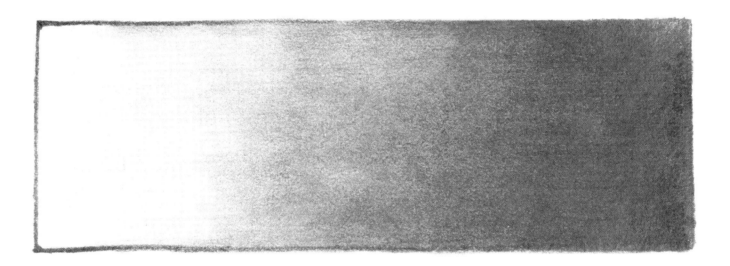

PRACTICE: On a blank piece of paper, experiment with a number of blending tools to soften edges and create smooth tones in graphite and charcoal. Refer to the blending tools on page 14 for ideas.

ATMOSPHERIC PERSPECTIVE

Atmosphere, or the air that surrounds us, impacts the viewer's perception of a scene. Subjects, edges, and details are sharp and clear up close, but as the subject recedes, the edges appear increasingly softer.

Using our understanding of diminishing contrast, tone, edge, and detail in a scene to convey depth is a very powerful tool, especially when combined with the laws of linear perspective.

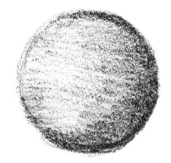
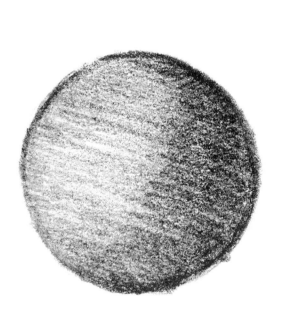

APPLYING THE PRINCIPLES:

Notice the visual effect of depth created in this illustration of five spheres. By making each sphere progressively smaller and toning each a bit lighter than the last, it appears as if the spheres are receding in space. Just using scale and value changes, we have applied the rules of diminution and atmospheric perspective to five simple circles.

Using the same principle of atmospheric perspective, let's apply our learning to a layered landscape scene.

PRACTICE: Draw a layered landscape scene using six lines, and then add tone.

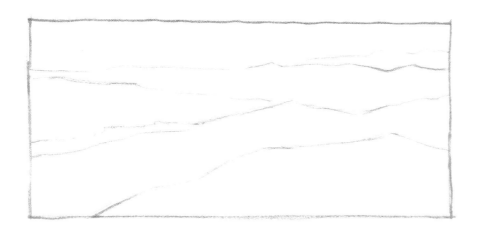

This layered mountain scene has about six value changes, getting lighter as each layer recedes toward the horizon.

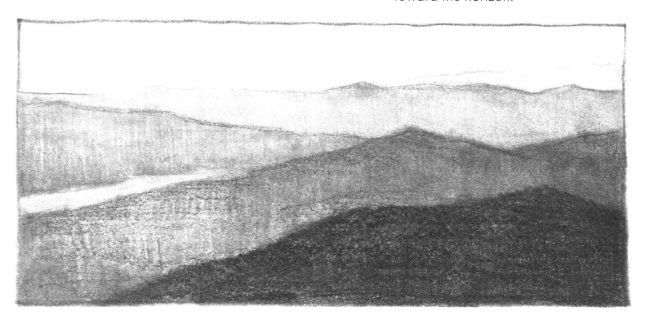

The foreground shoe is more detailed with sharper edges and crisp highlights; the back shoe falls into shadow, with less contrast and detail.

Dark compressed charcoal and black Conté push the values darker.

Rub in the charcoal with blending stumps, paper towels, and brushes to develop soft tones.

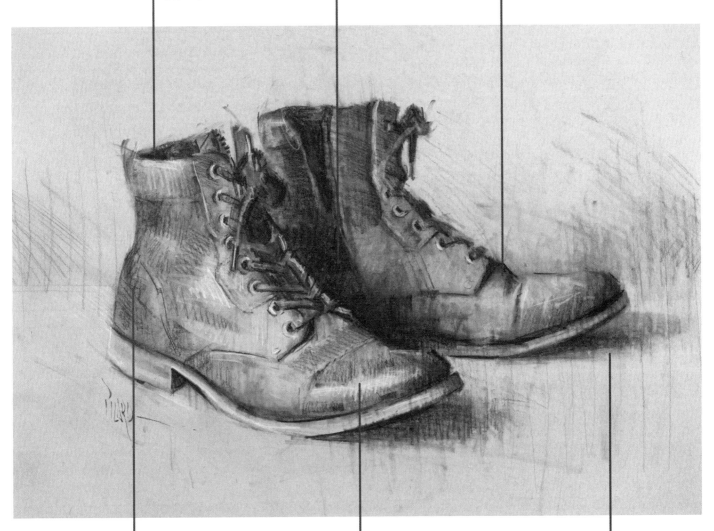

Build up the gritty texture on the boots with a variety of hatching techniques.

A white charcoal pencil pulls out the highlights.

Keep the edges on shadows under the boots soft.

Light & Shadow

The true subject of art is light. Artists study the effect of light falling upon the subject, revealing a pattern of light and shadow on the form. When we capture this convincingly in our drawings, we powerfully communicate the illusion of realism.

TO CONVEY SUBTLE GRADATIONS IN TONE, PRACTICE SHADING, APPLYING THE TONAL KEY TO LIGHT AND SHADOW.

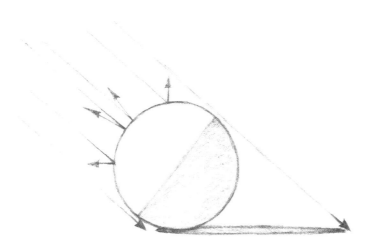

SHADING

Shading gives dimension to our drawings as we model form with lighter and darker values. A convincing application of these value changes gives the impression of light and shadow. Let's study the effect of light falling on a simple sphere from about the ten o'clock position (above and to the left).

Notice the pattern of light as it bounces off the sphere, revealing cast shadow.

Looking at the resulting light and shadow pattern, let's define six key terms:

1. HIGHLIGHT

The point where the light bounces directly off of the object opposing the light source is called highlight. White chalk and white paper cannot come close to replicating natural light, so we must greatly reduce and simplify our values to achieve the impression of light in a drawing.

2. LIGHT

This area represents the halo surrounding the highlight and the local value of the object as revealed by the light.

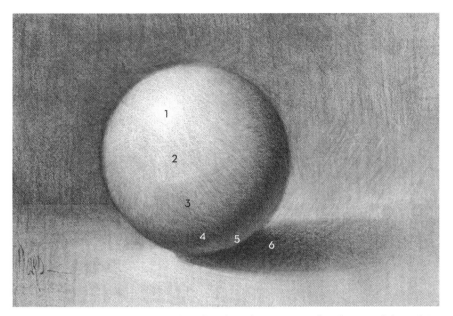

3. SHADOW

As the form begins to turn away from the light, we move into the shadow area, where the middle values, or halftones, are located. This area is crucial to create the illusion of depth and three-dimensionality.

4. CORE SHADOW

This is the line that distinguishes between lights and darks. This line will meander across the surface of an object, revealing where the light stops and the shadow begins as the form of the object turns away from the light source.

5. REFLECTED LIGHT

Lighter areas within the shadow that are caused by light reflecting off of surrounding surfaces is called reflected light. Artists commonly make the mistake of overstating reflected lights.

6. CAST SHADOW

A cast shadow is created when an object blocks the light source, thus "casting" a shadow across the surface of another form, such as the surface of a table. Cast shadows anchor the object to a surface, giving weight to the form.

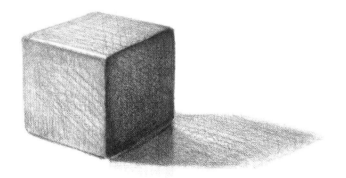

PRACTICE: Draw a cube, and use crosshatching to add tone. Notice the particular shape created by the cast shadow and the way the location of the light source changes this shape.

DISCOVERING LIGHT

Now that we have a basic understanding of the way light creates form, let's try to recognize the patterns of light and shadow as they fall across a scene. Take a single light source, such as a small spotlight or a lamp, and shine it upon an arrangement of objects. Group multiple objects into interesting shapes of light and shadow.

As you draw, focus on capturing the light and shadow pattern first by locating the core shadow on the objects right away. Keep shadow areas simple, and build subtle gradations of tone and texture in the lights, especially in the halftone areas between the lights and the core shadow.

Over time, your drawings will develop an amazing sense of realism, especially when correctly proportioned.

REMEMBER, SIMPLER IS BETTER WHEN IT COMES TO THE VALUE PATTERN. KEEP THE BIG IMPRESSION OF THE VALUES, AND CONTAIN YOUR DRAWING WITHIN THE NINE-TONE VALUE RANGE PLUS WHITE.

PRACTICE: Draw a still life with a strong pattern of light and shadow.

Notice the strong pattern of light and shadow on this sheep and the core shadow revealing the shadow pattern. The cast shadow on the ground gives weight and grounds the image.

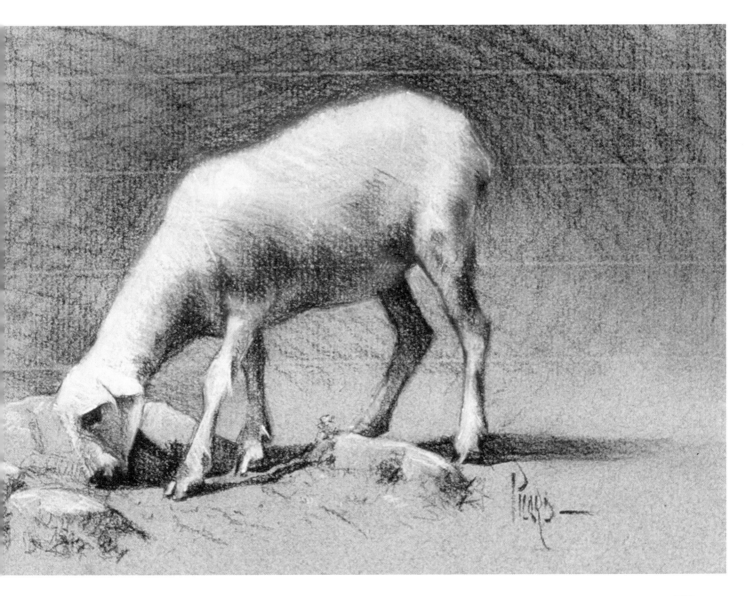

LEARNING TO SEE

In this graphite study of an artist's mannequin, along with wooden blocks and a pair of eyeglasses, I took a number of unique objects and grouped them together in an interesting and unified pattern of light and shadow. Although it took a lot of time to develop and add the subtlety of form in the drawing, I kept the value range simple and clear.

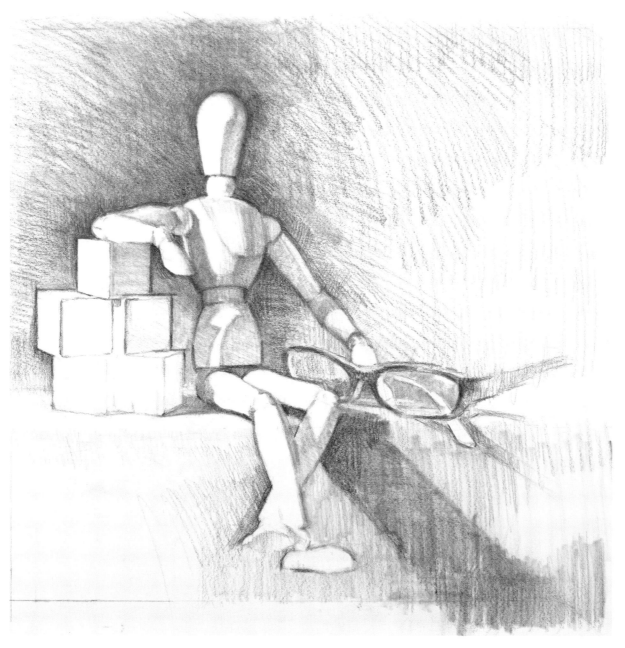

About this work: The inspiration for this still-life subject, "Learning to See," was this book's major theme of learning to draw and develop a new visual vocabulary. The wooden blocks represent the building blocks of our new visual language, and the glasses signify learning to see anew with artists' eyes. Finally, the artist mannequin symbolizes the visual arts, inviting us into the pursuit of learning to draw.

Notice the right arm (your left), which is propped up on the blocks, casting a shadow on the mannequin's body.

This drawing has a lot of tonal buildup.

A large triangular shape is created by grouping the light areas from the wide base of the illuminated tabletop to the top of the mannequin's head.

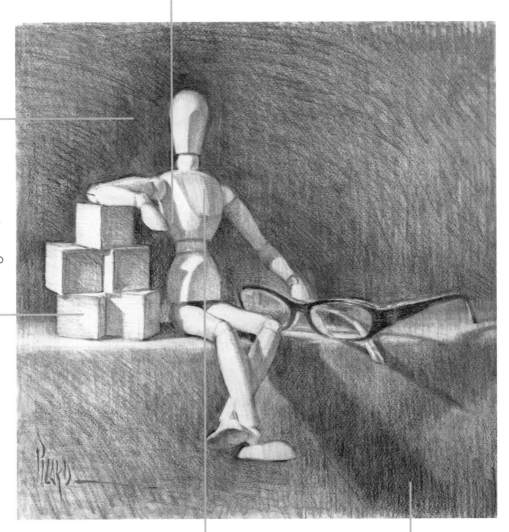

You can see the core shadow meandering down the mannequin's body from the top of the head to the bottom of its feet, giving clarity to the form.

You can see from the long cast shadow on the drapery that I've placed the light source above and to the left of the still-life arrangement at approximately the 10:30 position on a clock.

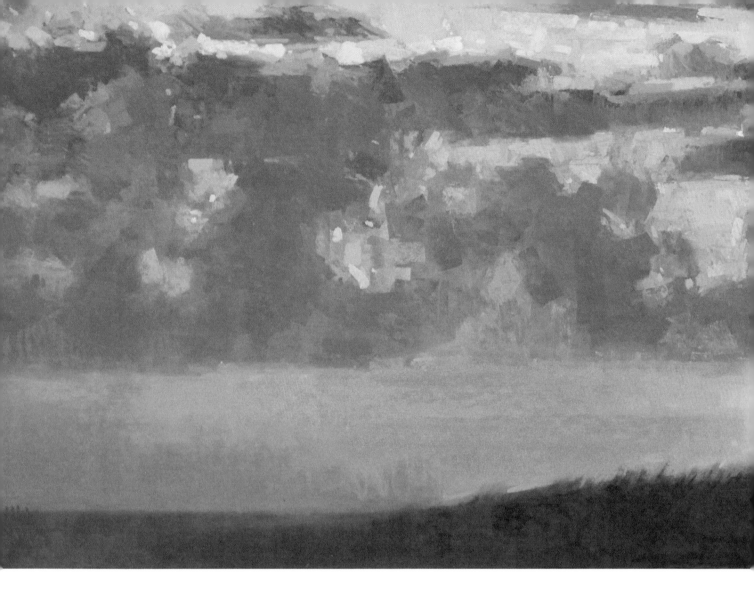

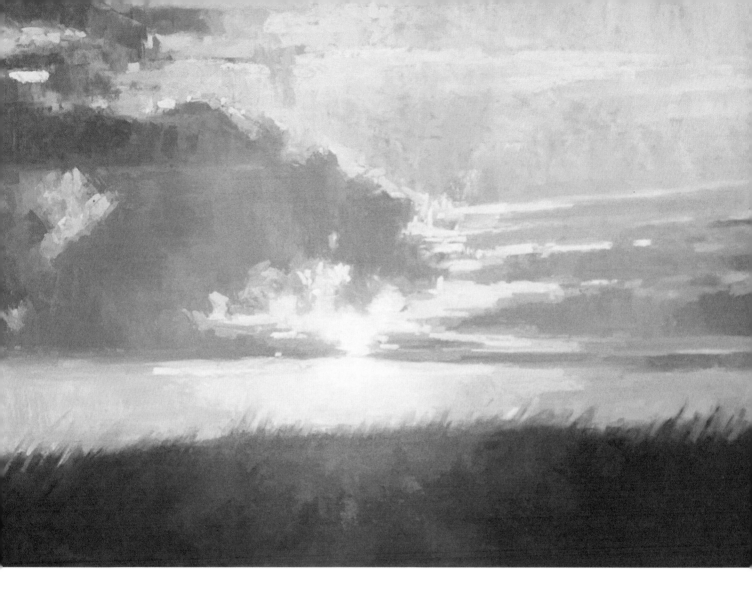

Designing a Strong Composition

Design doesn't have to be intimidating. It simply means the arrangement of elements within a picture. Every picture has a design, whether it is good or bad, interesting or dull, intended or unintended. In this section, you'll learn how to develop strong, engaging compositions in your artwork.

One of the most important aspects of clarifying your design concept is to simplify your image down to about three to five simple shapes, and organize them in a visually pleasing way that emphasizes your pictorial concept. To do this, you'll need to learn how to simplify the subject matter in your scene to flat shapes using no more than three to four values. Creating thumbnail sketches is the best way to do this quickly.

THUMBNAIL SKETCHES

Thumbnail sketches help you design your drawing from the start. Make a number of quick sketches to determine the cropping, shape, and placement of your subject. You can use a variety of drawing media, from ink markers to graphite, charcoal, and Conté crayon. Permanent markers work well too.

I try to meet the following three goals in the thumbnail before moving on to a finished piece of art.

1. **SIMPLIFY THE VALUES.** By squinting, you can see the big masses of dark and light in the scene and arrange them into a pattern of value shapes.

2. **CLARIFY THE SHAPES.** Reduce the dizzying array of subtlety and detail in your subject to three to five simple shapes, and organize your shapes in an interesting way to communicate your vision. Remember, you are the director of this production, and every member of the cast should be working to achieve your vision. There can only be one star of the show, so choose your lead wisely!

3. **DESIGN THE COMPOSITION.** Sketching small and quickly, try your scene in both vertical and horizontal rectangles, square format, and even panoramic to discover which approach will bring your concept to life most effectively.

DON'T IGNORE DESIGN JUST BECAUSE YOU ARE INSPIRED AND WANT TO GET TO THE REAL THING! NO AMOUNT OF DETAIL WILL SAVE A POORLY DESIGNED DRAWING, SO TRY TO GET IT RIGHT FROM THE START. INVESTING EVEN 10 MINUTES TO DEVELOP A STRONG DESIGN WILL IMPROVE THE WORK TREMENDOUSLY.

Adjusting how you crop in on the scene changes the size of your negative shapes, and this impacts the overall balance.

Use variety in your edges, from soft to broken to hard.

Create a variety of lines and shapes: large and small, simple and complicated, quiet and busy.

Simplify areas to support your main idea. Don't add lots of detail and information.

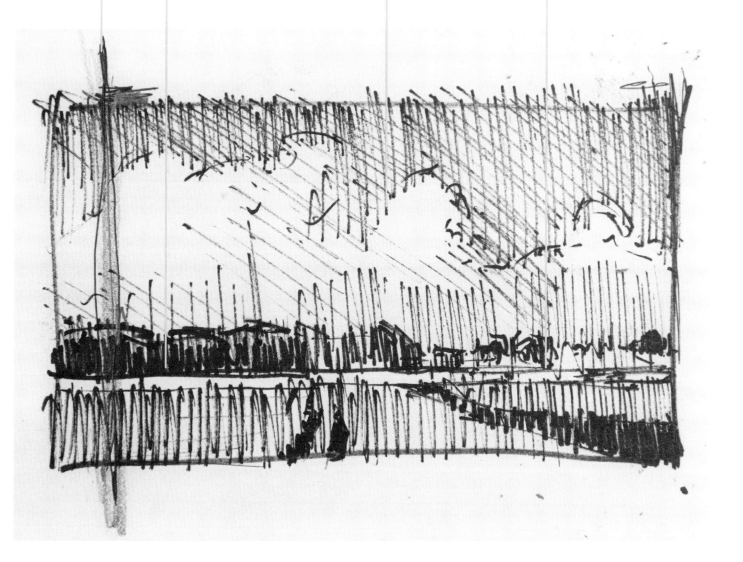

BALANCE & HARMONY

Harmony creates a bridge that connects disparate elements through a common attribute, whether it's texture, tone, shape, or line.

Consider using darks to guide the eye through the work, and create interesting patterns, such as S-curves and zigzags. As you sketch, don't be afraid to draw lines around your shapes to reveal the interplay of balance.

The tonal approach of this graphite study unifies all of the main shapes into a harmonious design.

This is the dominant middle-dark value.

The open edges keep the viewer's eye from leaving the picture by traveling down the riverbed and out to the bottom left.

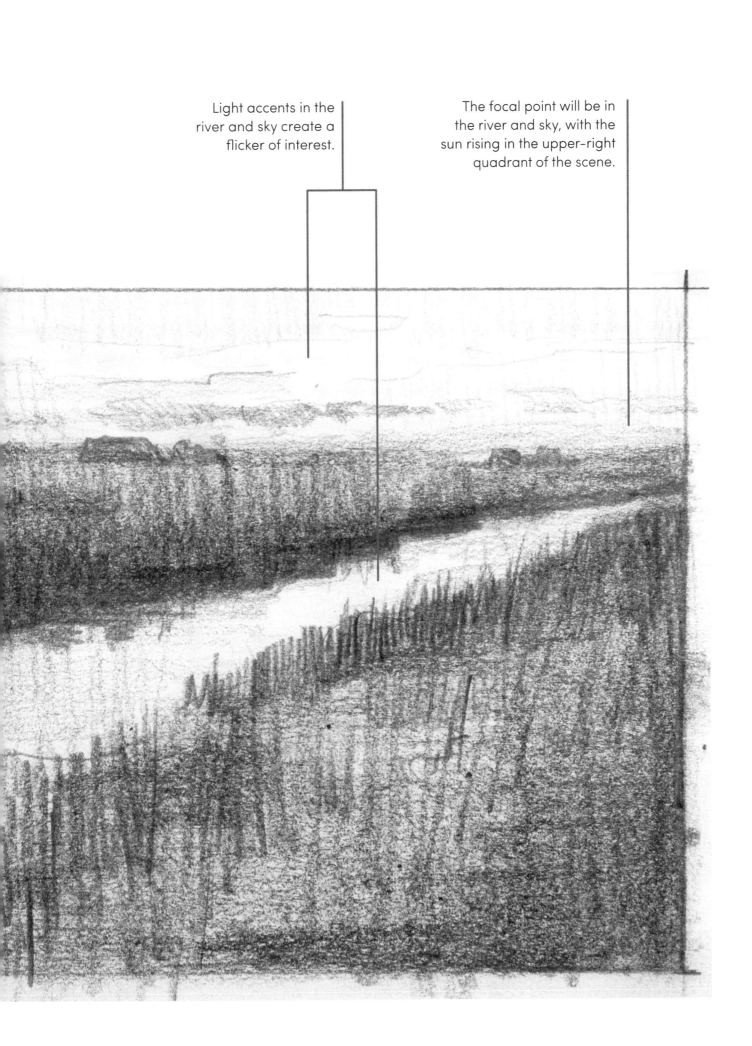

Light accents in the river and sky create a flicker of interest.

The focal point will be in the river and sky, with the sun rising in the upper-right quadrant of the scene.

VISUAL UNITY & RHYTHM

Always work toward visual unity, so your main idea prevails and everything else supports your concept. Repeat lines, shapes, values, and edges to tie the work together and establish rhythm. Look for ways to direct the viewer's eye through the scene, using line to develop your concept.

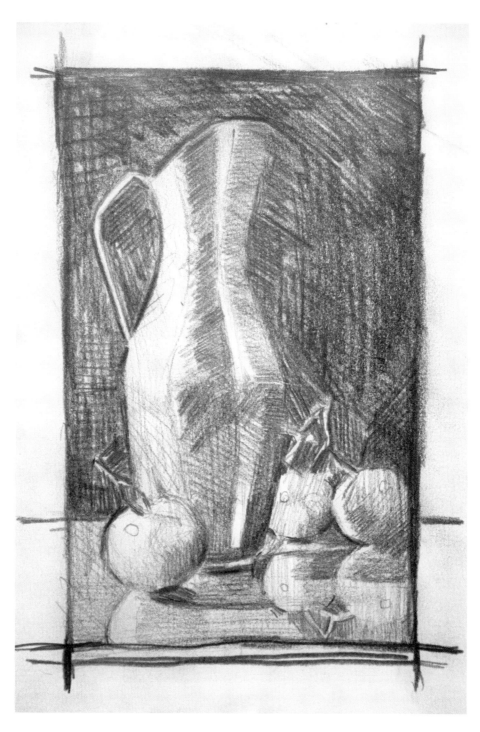

Notice the cluster of activity and interest in the lower third of the scene that's formed by the tomatoes and the reflection on the tabletop. The pitcher serves as a long visual counterpoint, with thin reflections in the vase leading the eye upward. A dark dominant value establishes a strong mood.

This thumbnail sketch has a square composition, a dominant dark value, and a light accent at the focal point of the rose. Variety comes from the big and small shapes; quiet background; and small, bright leaves and petals.

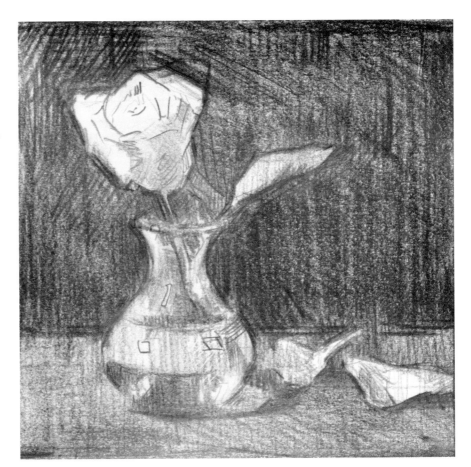

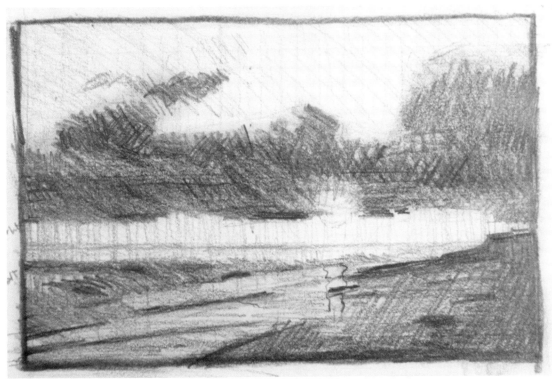

This scene features a wonderful variety of shape relationships and a pleasing balance between the negative shapes of sky against the clouds. The cloud mass is established simply, along with the triangular beach shape at the bottom right, beside water and sky shapes. The horizontal format emphasizes the movement of the clouds over the beach.

DESIGNING FOR DEPTH

Another way to create an interesting design is to determine a clear foreground element, middle-ground shapes, and a background. This makes the scene look vast and invites the viewer to enter one of the many layers.

This charcoal, white Conté, and gray pastel study on toned sketchbook paper works out the essential value and design shapes in a Cambodian landscape painting of a rice paddy.

This study reveals the use of clear foreground, middle ground, and background sections, emphasizing depth.

The strong shape of the sugar palm tree in the upper right center anchors the dark values of the scene.

The vanishing point on the river creates an inviting flow into the design, leading from front to back. This brings the eyes into the scene via the strong foreground riverbank lines and then takes them through the interesting shapes of the middle ground.

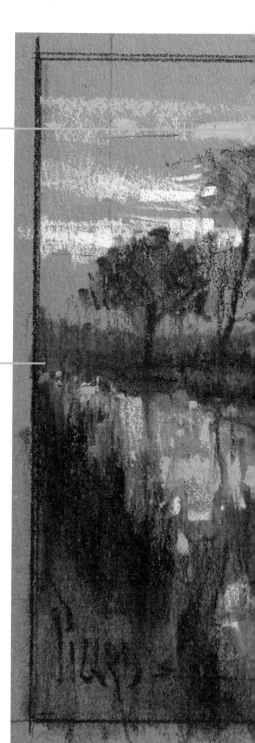

There are nice varieties of tree sizes and shapes moving through the middle ground of the scene as we enjoy the sunrise.

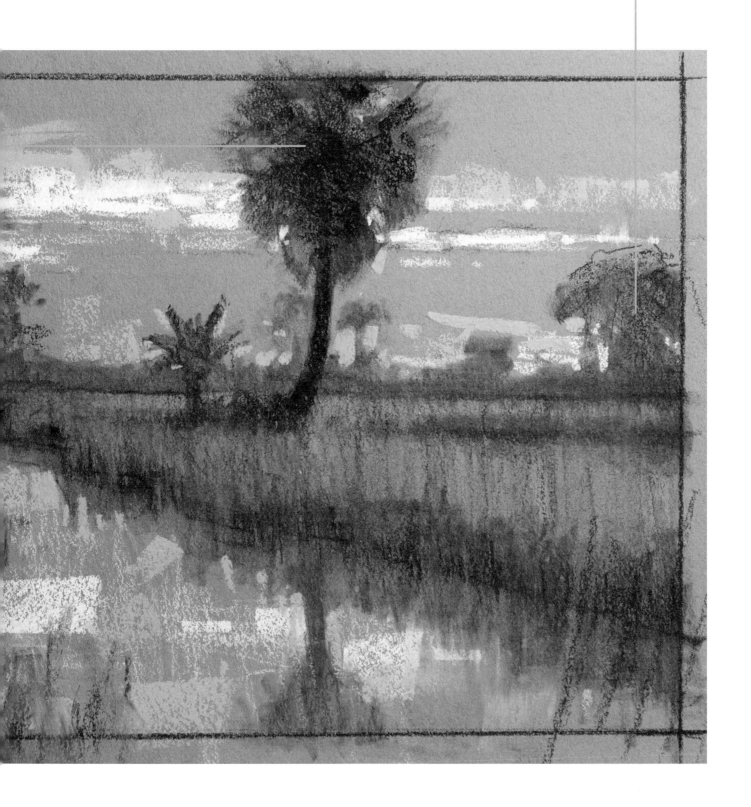

THE RULE OF THIRDS

When determining your focal point, consider using the rule of thirds.

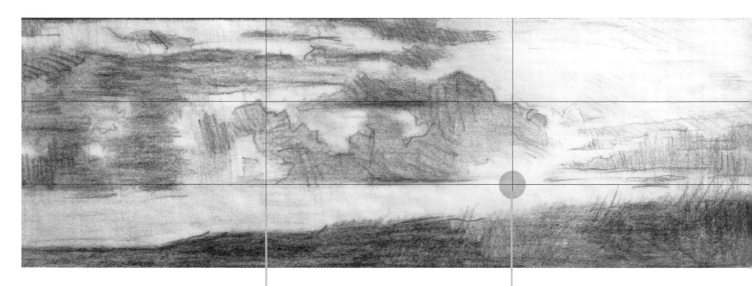

Divide your image into thirds with two horizontal lines and two vertical lines.

These intersections become hot spots, or pleasing locations, for focal points in your design. The focal point of this scene is a sunrise.

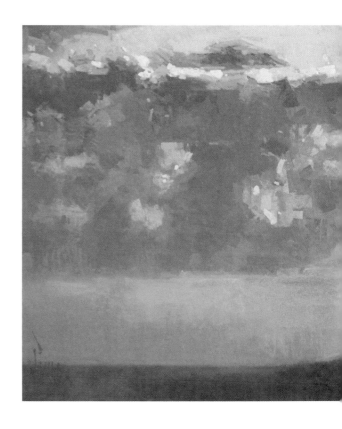

AVOID SPLITTING A LANDSCAPE SCENE IN HALF AT THE HORIZON LINE, AS THIS CAN LEAD TO A BORING COMPOSITION.

Another effective use of the rule of thirds is to divide the land and sky of a landscape painting so that the sky accounts for two-thirds of the available space and the land accounts for one-third. This ratio creates a more interesting composition.

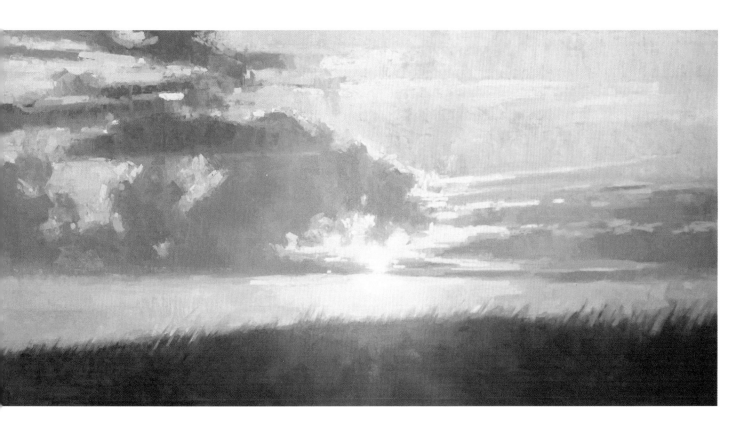

THE GOLDEN RATIO

When you look deep into the natural world, you'll discover that a dominant proportional ratio is responsible for much of its design. The Greeks called this proportion "the Golden Ratio," and it translates to approximately 1.618 to 1. Continuing to add this relationship of 1 to 1.618 to create a summation sequence is called "the Fibonacci Sequence." This sequence matches growth patterns found throughout nature and is clearly identifiable in the beautiful pattern of the nautilus shell.

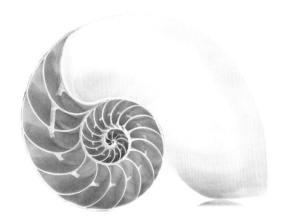

Nautilus shell

The Fibonacci spiral, like the nautilus shell, is based on the Golden Ratio, and it follows the Fibonacci Sequence to create a visual focal point in the rectangle. This can create a great starting point for your design.

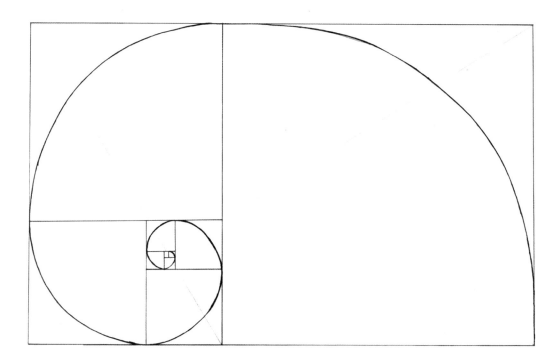

Fibonacci spiral: The rectangle around this spiral is based on the Golden Ratio. Notice the succession of squares that rotate progressively smaller around each other in perfect order, creating a spiral pattern that diminishes in size toward the focal point.

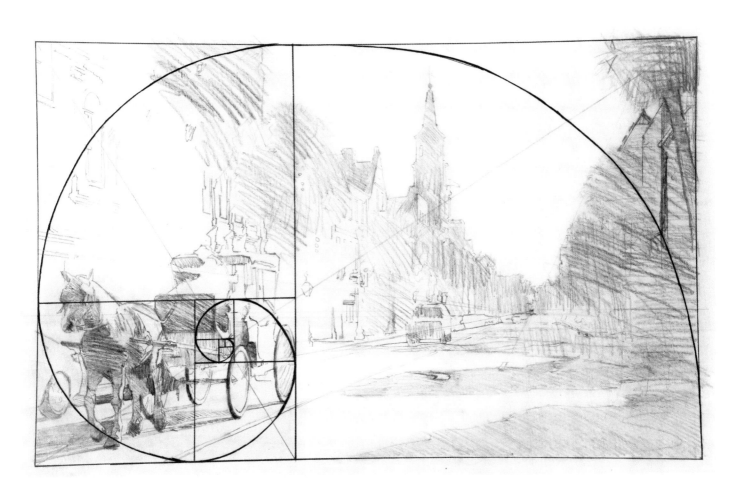

*Notice how the horse and carriage have been carefully located
within the focal point of the Fibonacci spiral in this design.*

DESIGNING THE STORY

There's nothing quite as magical as the bustling Southern charm of downtown Charleston, South Carolina. This drawing captures the grandeur of Broad Street, which you might experience while taking a carriage ride.

The secondary focal point, the church steeple, is a supporting cast member. It's lighter in value and contrast, so it doesn't steal the show from the horse and carriage.

The promenade on the left side of Broad Street is sunlit and sparkling.

I used the design principle of the Fibonacci spiral to anchor the main focal point of the horse and carriage in the lower-left quadrant of the scene. The darkest darks and the sharpest contrast have been reserved for these stars of the show.

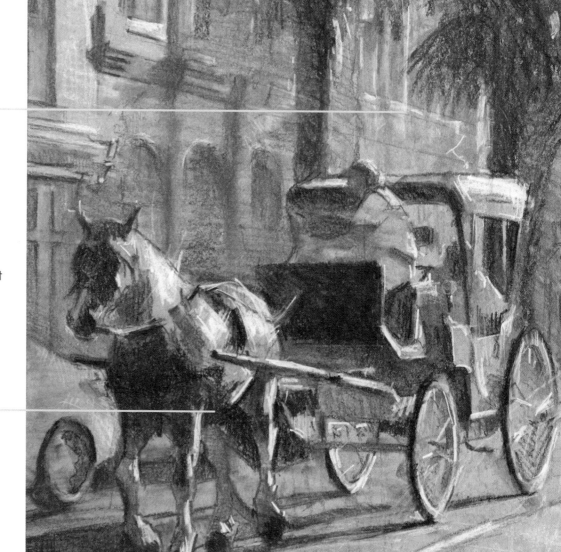

The angular and complicated rooftop line provides further variety and interest. By restraining tonal variation, the overall shapes remain simple and strong.

Notice the harmony between the light and dark shapes as well as the negative shapes of the sky against the city.

The long shadows falling across the street direct viewers' eyes back toward the focal point.

The far side of the street is shrouded in shadow.

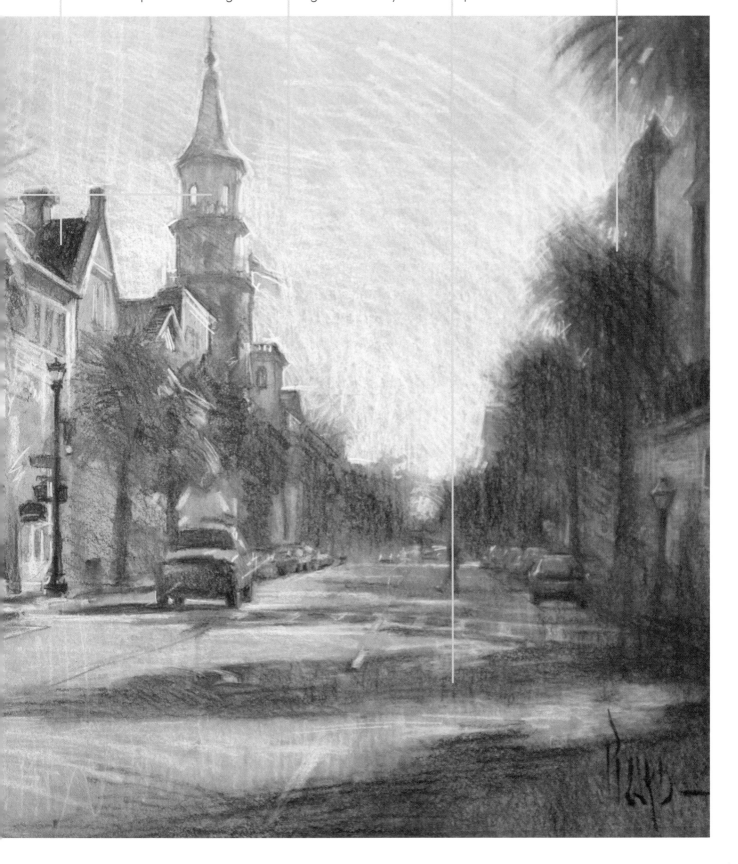

Mastering

WHAT YOU'VE LEARNED

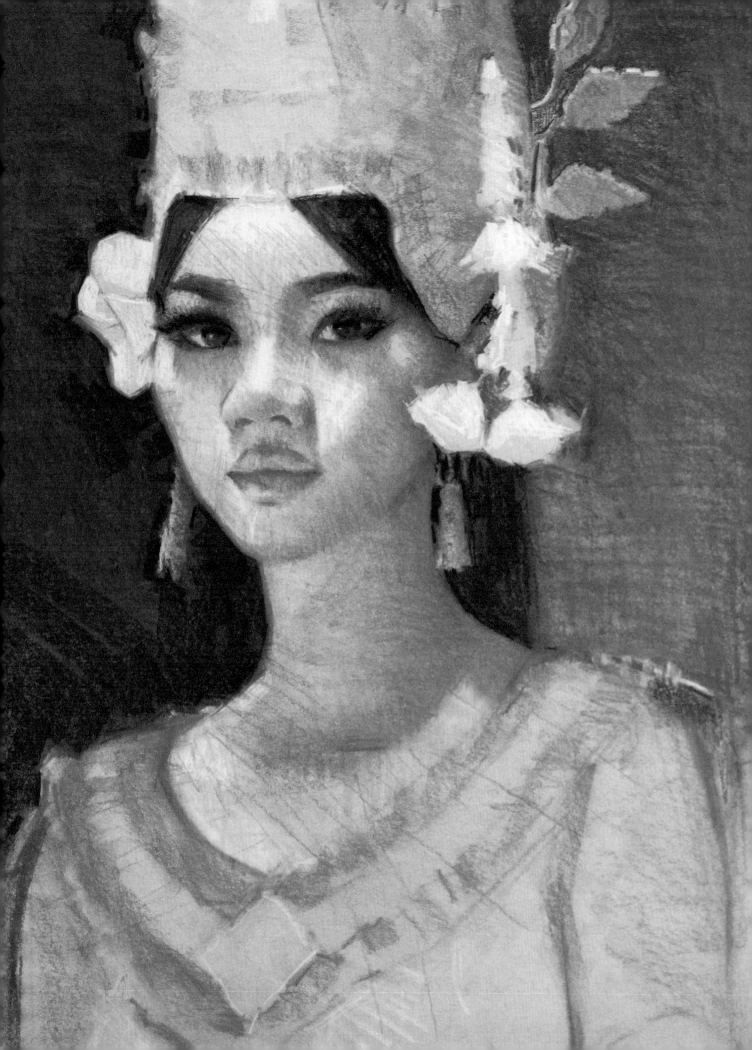

Ballet Dancer

This project focuses on capturing a sense of movement in the figure of a ballet dancer. We'll be working on a gray-toned paper with soft vine charcoal along with black, white, and umber hard pastel sticks.

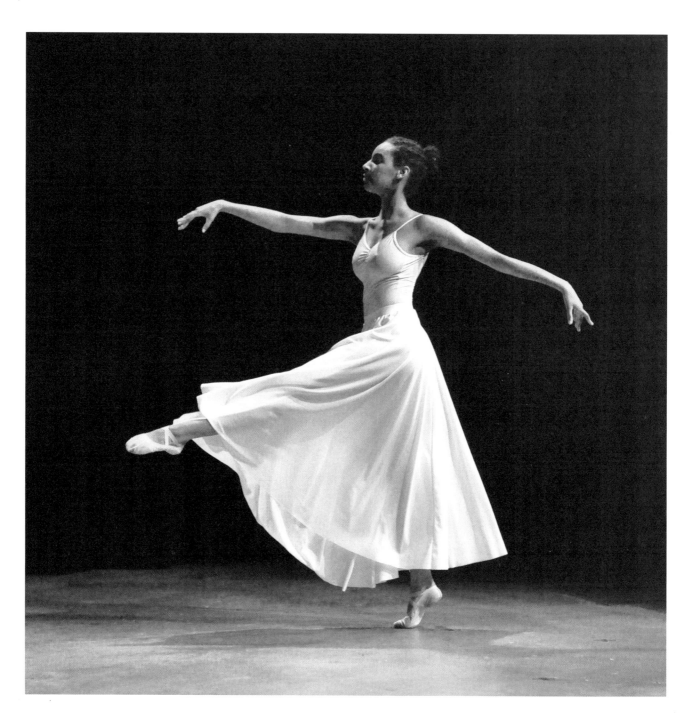

When dealing with the full figure, it is very helpful to begin by scaling the figure to the length of the paper.

Using the visual habit of measuring, create a unit of measurement for the head of the dancer. Six of these units bring you to the bottom of her foot. One additional unit is needed below the foot for her shadow.

Using soft vine charcoal, sketch in the angle of the arms, legs, and body using the angularizing habit. You'll begin to capture the big gesture of the dancer in motion.

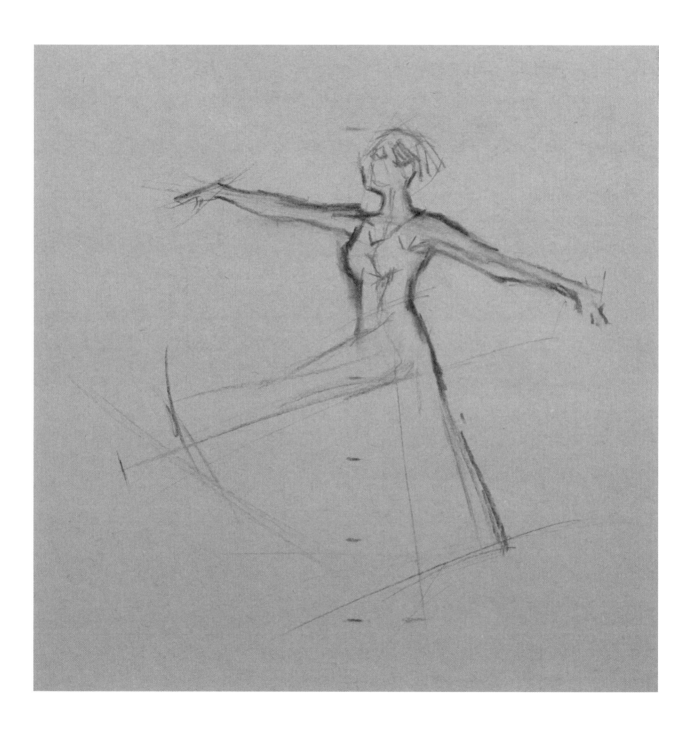

Work your way around the whole figure with soft vine charcoal to capture the overall shape and gesture of the form.

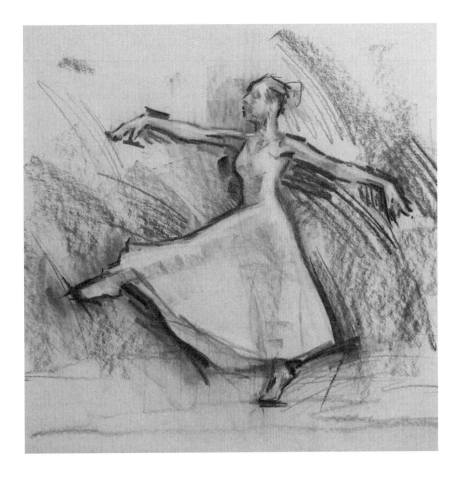

Vine charcoal **IS VERY FORGIVING, ALLOWING YOU TO FIND THE DRAWING WITH THE ABILITY TO RUB OUT AND MAKE EASY ADJUSTMENTS.**

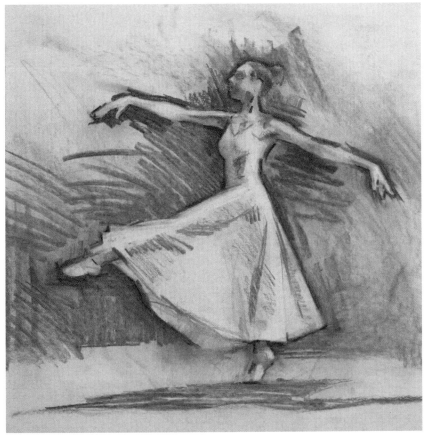

Start adding tone with charcoal, using linear and tonal sidestrokes.

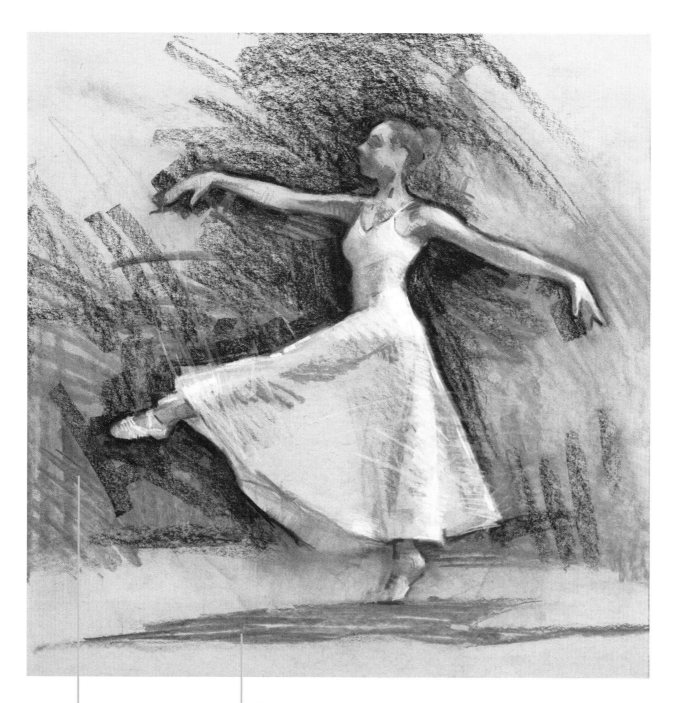

Rub in the charcoal with a paper towel and blending stumps to gain subtle gradations.

Then add the shadow below the figure to ground it, and build up tone with more charcoal hatching.

Now the figure begins to emerge from the background in a clear and definable space, and the overall scene is established.

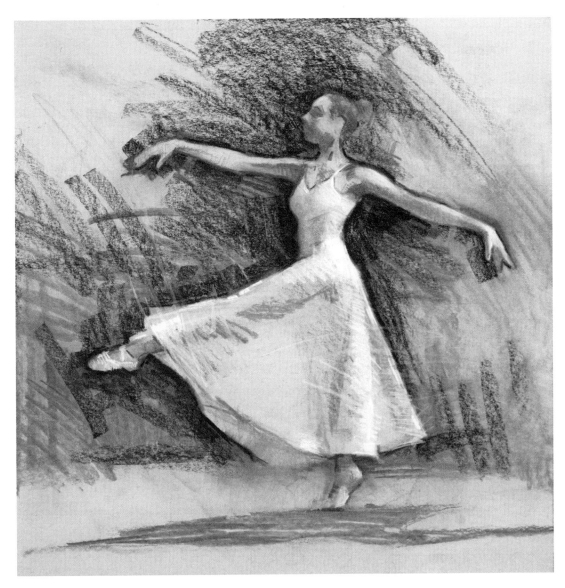

Now it's time to develop the values with greater contrast and clarity by using the black hard pastel in the darks around the figure and the white charcoal pencil and white hard pastel on the dress. Use a small amount of umber hard pastel to give warmth and tone to the dancer's skin. As you add these marks, emphasize the movement of the dancer, even with the shadows behind the figure.

It's time to refine the drawing toward our goal: conveying movement. In this stage, bring aspects of the image into focus while loosening up other sections. Be careful not to overwork it and lose the airy feel!

Emphasize the contour to create a beautiful overall shape. Blending stumps and tortillons soften edges and make subtle gradations.

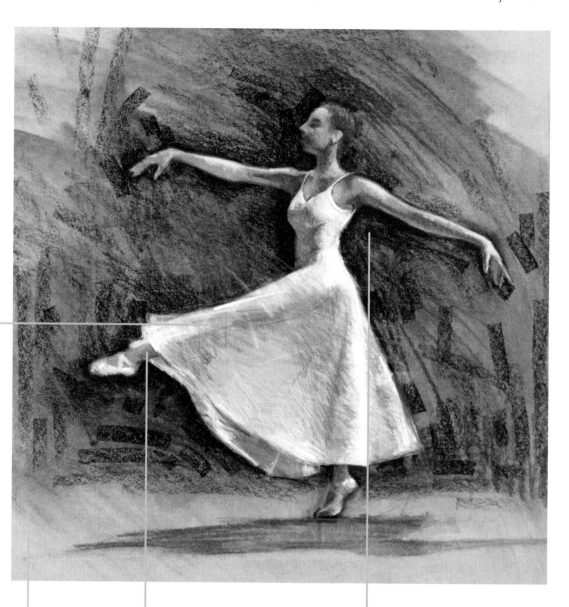

Larger stumps create dynamic movement and energy in the foreground and background.

Refine the dress with greater detail using white charcoal pencil, and refine the skin with brown.

Blend some of the darker black pastel into the background to create more depth in the darks.

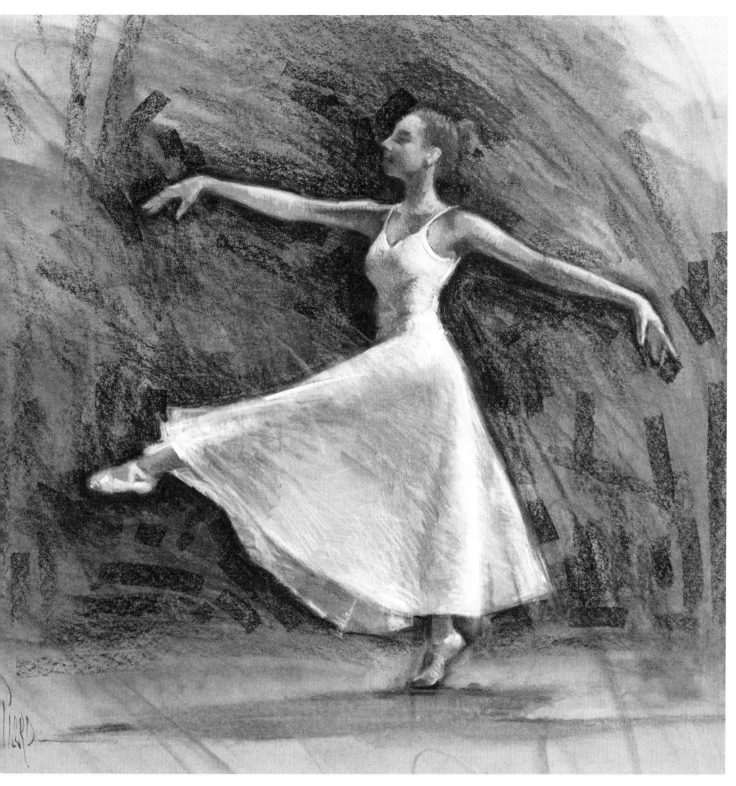

This final drawing communicates an exciting sense of movement.

Sugar Palm Over a Rice Field

The goal of this project is to practice designing for depth in the landscape by creating clear foreground, middle ground, and background elements. This conveys space and dimension, inviting the viewer to enter the various layers found within the scene. Our landscape drawing will explore a Cambodian rice field at sunrise, featuring a lovely sugar palm tree.

MATERIALS USED

We'll be working on a brown-toned paper with various forms of charcoal and Conté pencils as well as white, black, and umber hard pastels.

With a pencil, lightly sketch out the main shapes of the scene, including the horizon line, riverbanks, and larger trees.

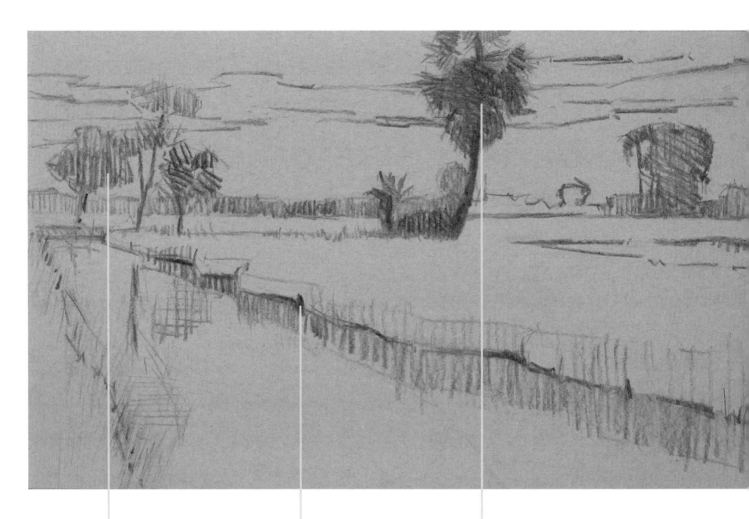

Using soft vine charcoal, sketch in the main shapes again loosely, adding more definition and linear hatching.

The strong lead in lines of the riverbank already work to invite the viewer into the scene and lead them through an interesting variety of tree shapes in the middle ground.

The strong shape of the sugar palm tree in the upper middle right is a focal point that anchors the dark values of the scene against the sunrise breaking through the clouds in the background, now indicated through the sky.

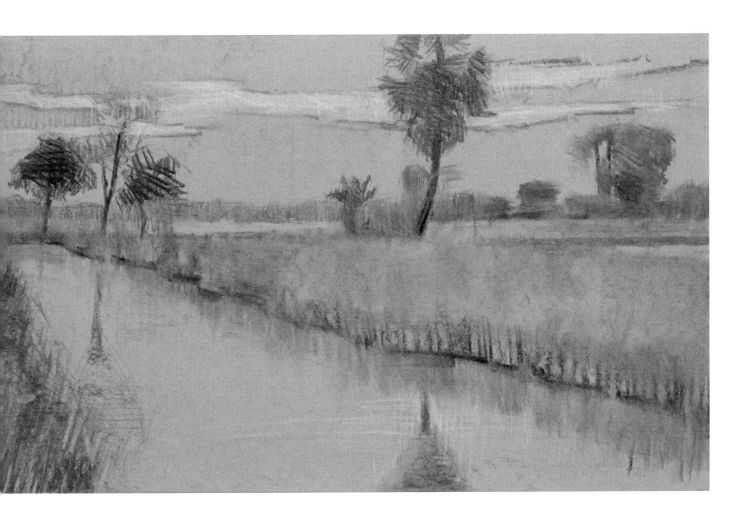

Use a blending stump to soften the tone in the rice field and trees and develop reflections in the water. Then moving to a black Conté pencil, push the values darker and add more texture in the darks.

Use a white charcoal pencil to indicate the light breaking through the clouds in the sky and reflecting in the water below. Now the design takes on impact with the developing tonal range.

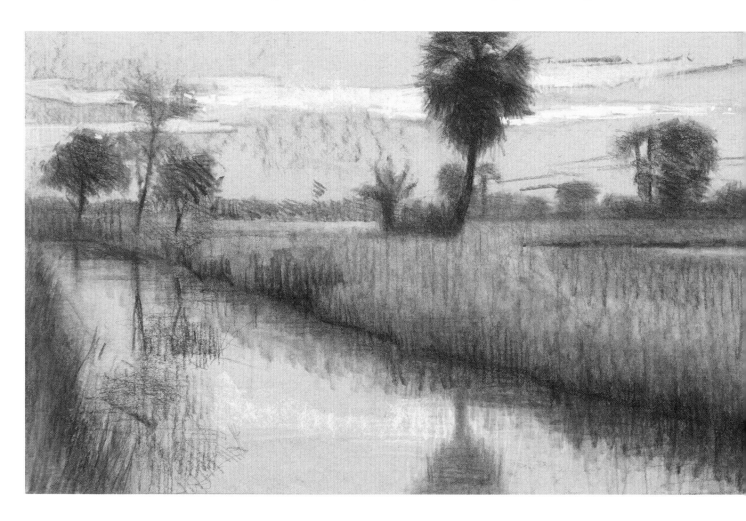

Develop the values
a step further by
pushing the darks
to full impact.

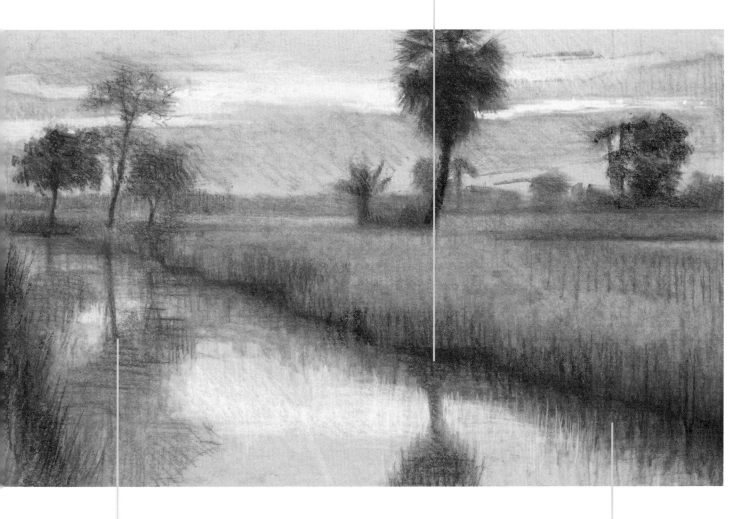

Get those patterns
of reflections
working together in
the river.

Evaluating the foreground
diagonal, create a balance
between the grasses by the
riverbank and the reflections in the
water to guide the viewer back to
the trees in the middle ground.

Blend and refine the lights in the sky.

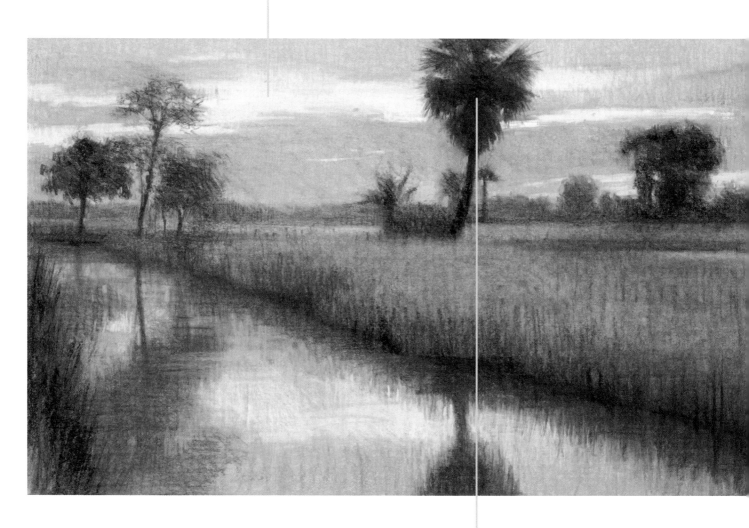

Continue to develop
the shape of the
main sugar palm.

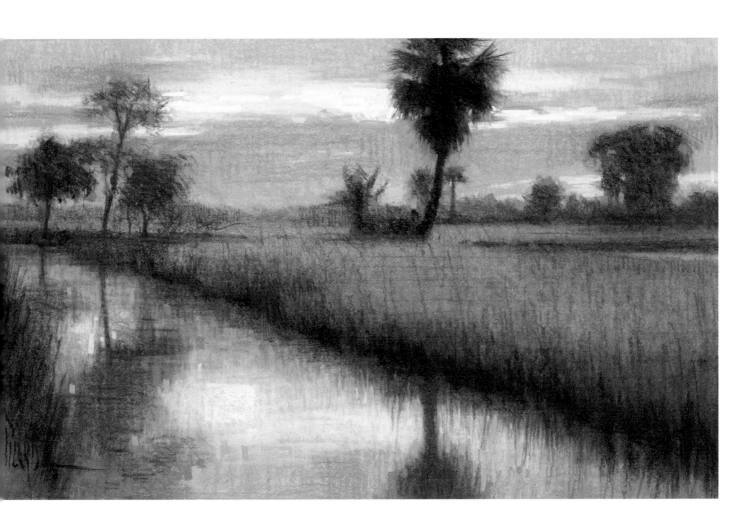

With the full drawing developed, refine it by adding warmth with an umber hard pastel as well as additional white pastel buildup in the sky and water. Further refinement of shapes and details is accomplished in this stage as well. Given the early morning tone, ensure there are enough midtones in the sky to allow the light to break through. Now that you can experience the three layers of foreground, middle ground, and background working well, you're finished.

Apsara Dancer

In this project, you'll use a limited palette of white, ochre, sanguine, brown, and black to give the impression of lifelike color in your drawing.

MATERIALS USED

We will be using a brown-toned paper; soft vine charcoal; charcoal and Conté pencils in white, sanguine, brown, and black; and hard pastels in white, ochre, and black.

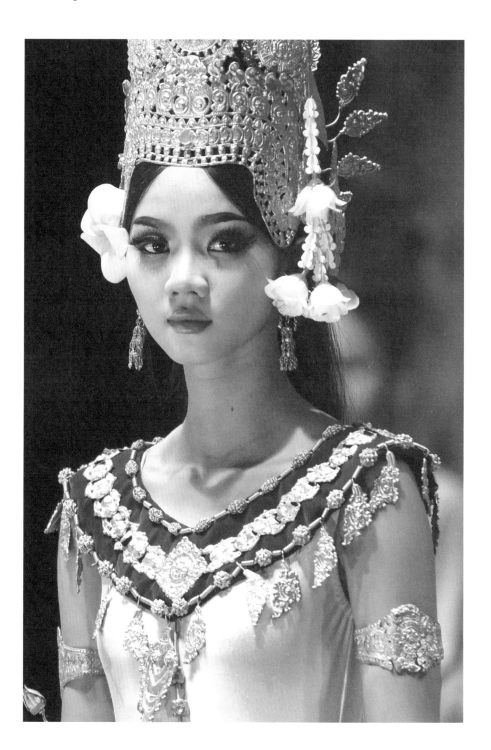

The first half of this project involves the basic drawing of the head and upper torso. The second half develops the drawing by refining and tinting the portrait with a limited palette of earth colors.

The first order of business in drawing a portrait involves scaling the head to fit the paper. Place a charcoal mark for the line dividing the dancer's headdress from her forehead. Another line for the chin sets the size of the visible head, and creates a unit of measurement.

From there, measure and record the outside edge of the head, flowers, and headdress. Use the visual habits of squinting, angularizing, measuring units, and using level and plumb to find location points where major angles change direction.

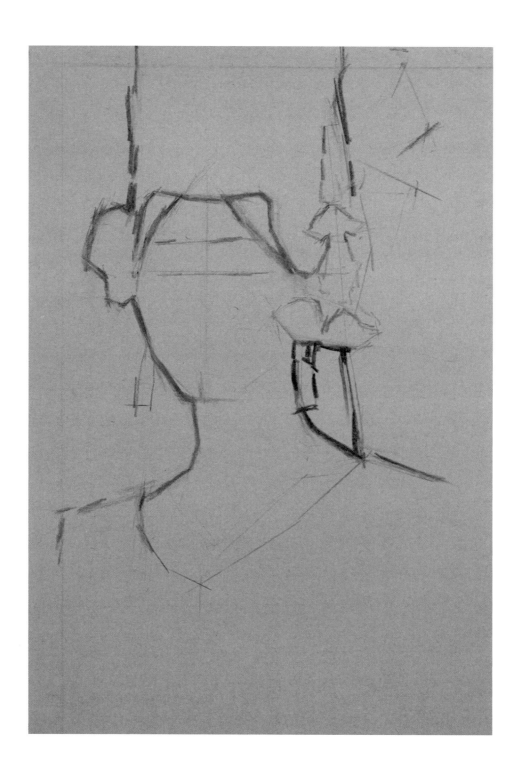

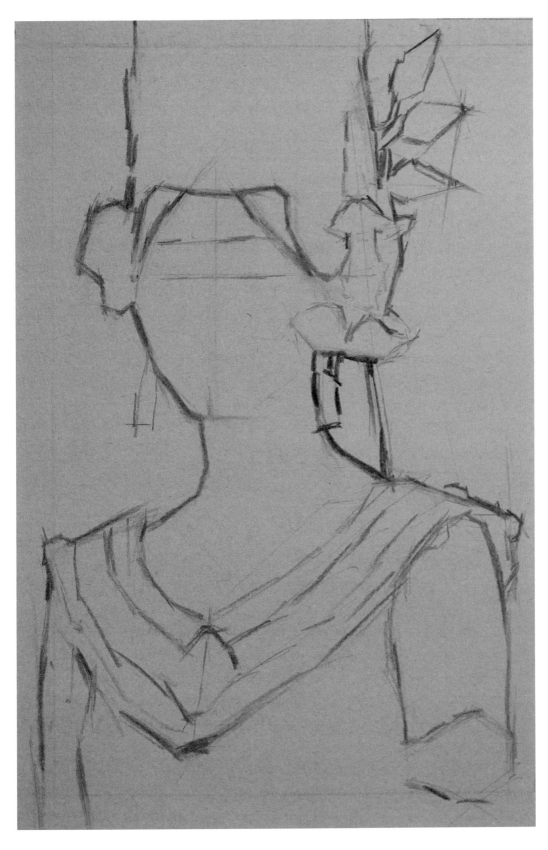

Continue to build the major shapes of the neck, shoulders, and torso by measuring them in relationship to the head. Gain confidence in the drawing with soft vine charcoal. Using units of measurement, check to see that the body is in correct scale and proportion to the head.

Now that the main shapes are established, begin to add tone with vine charcoal by using the side of the stick as well as making linear strokes.

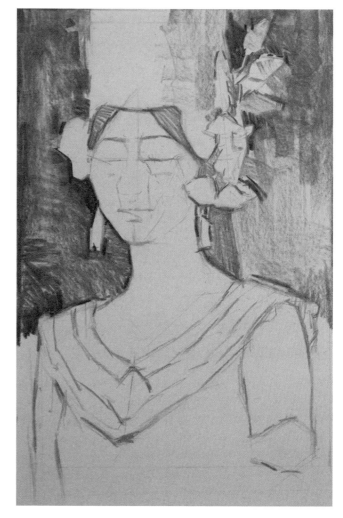

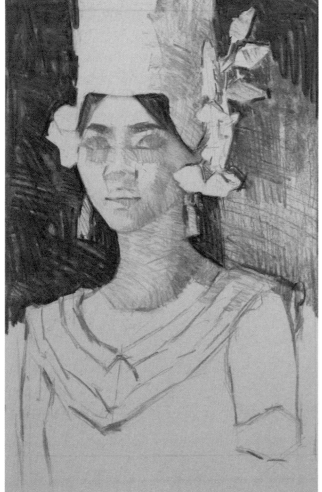

Build the features of the face by finding the major location points for the eyes, nose, and mouth and the division of light and shadow on the face, neck, and headdress.

Use blending stumps to soften the texture of the charcoal and develop soft tonal effects at this stage. This gives a soft hazy effect before going further into the darker, more permanent tones.

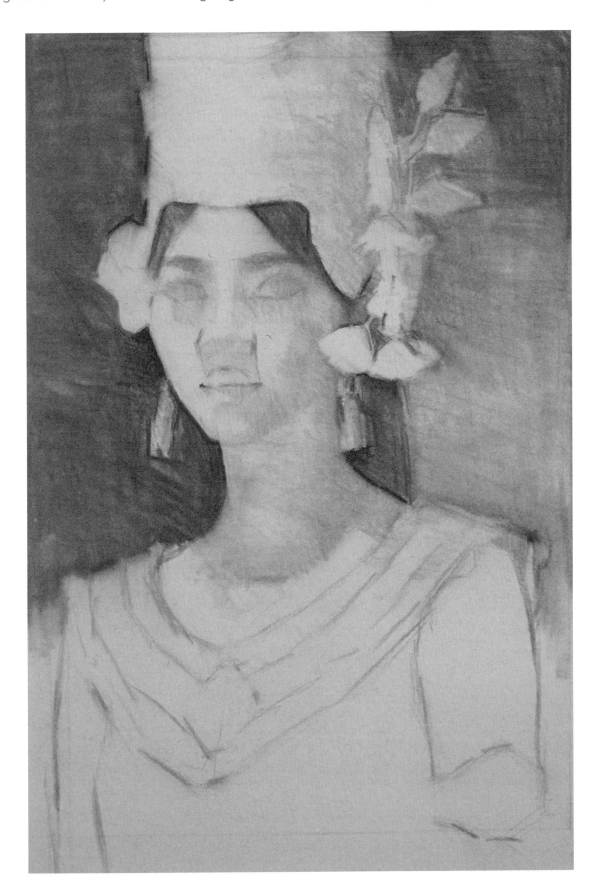

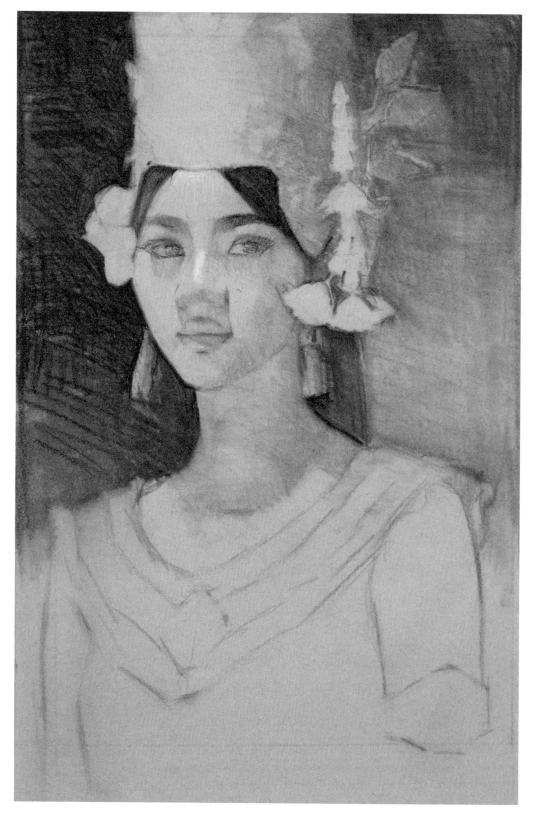

Now it's time to use the Conté pencils to anchor the darks with a permanent black tone. Notice the strong negative shape in the top left background and the small dark shapes of the hair that frame the face. Observing negative shapes is an important visual habit when dealing with complex forms! Using a sanguine Conté pencil for linear marks and a square Conté stick for sidestrokes, begin to tint the drawing with the warm sanguine tone.

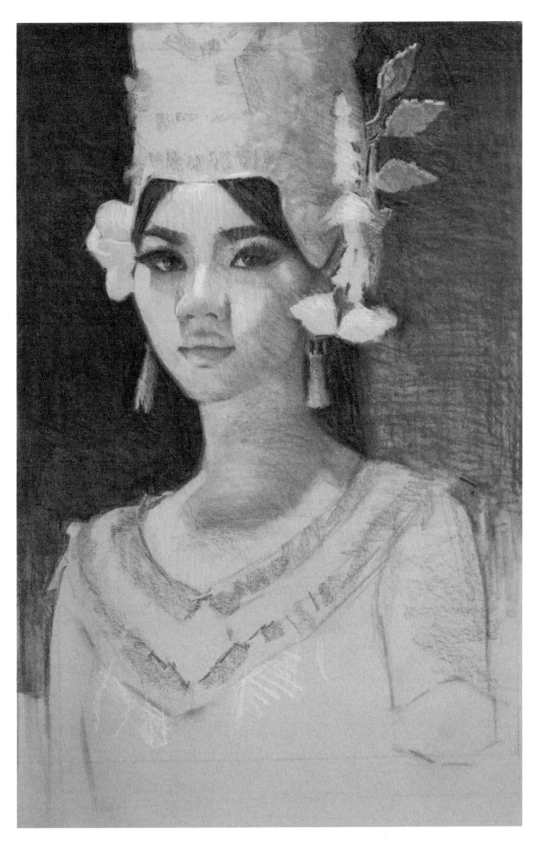

This quickly brings the portrait into the fleshy warmth that we are after. Use a brown Conté pencil to bring a warm middle dark to the background on the right behind the head. Use the sanguine stick to build up flesh tone on the skin and warmth on the ornamental chest piece.

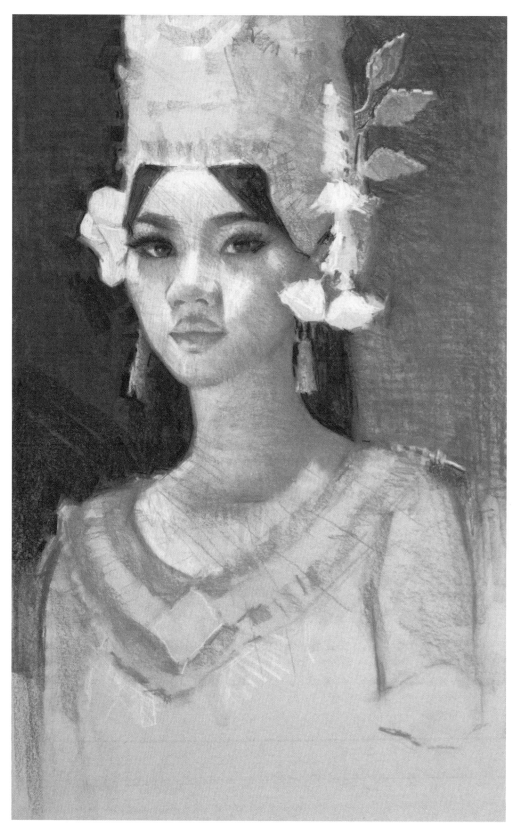

Finally, use a white Conté pencil to add light value to the flowers, face, and chest. This brings the full contrast of the image to life. Use blending stumps and tortillons to blend the skin and background tones into subtle gradations.

The last earth color to add to the drawing is a yellow ochre hard pastel, which gives a wonderful warmth to both the light tones of the face, golden headdress, and chest piece.

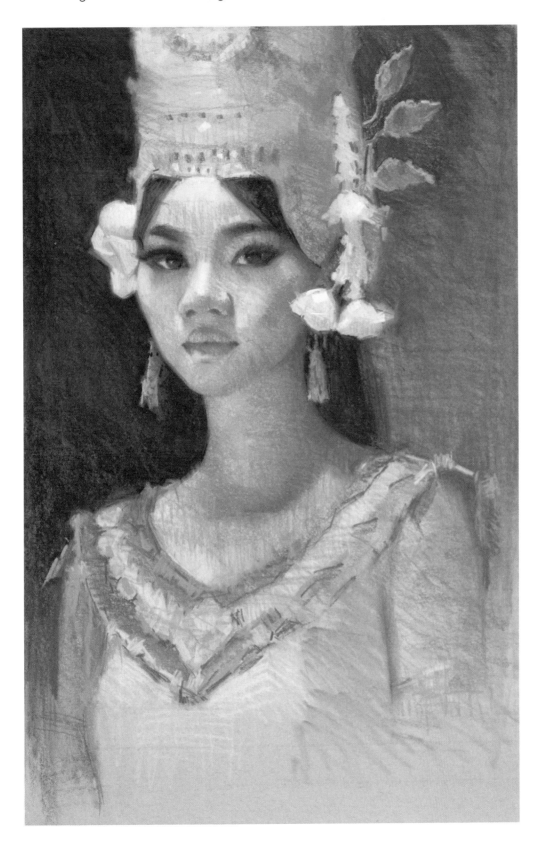

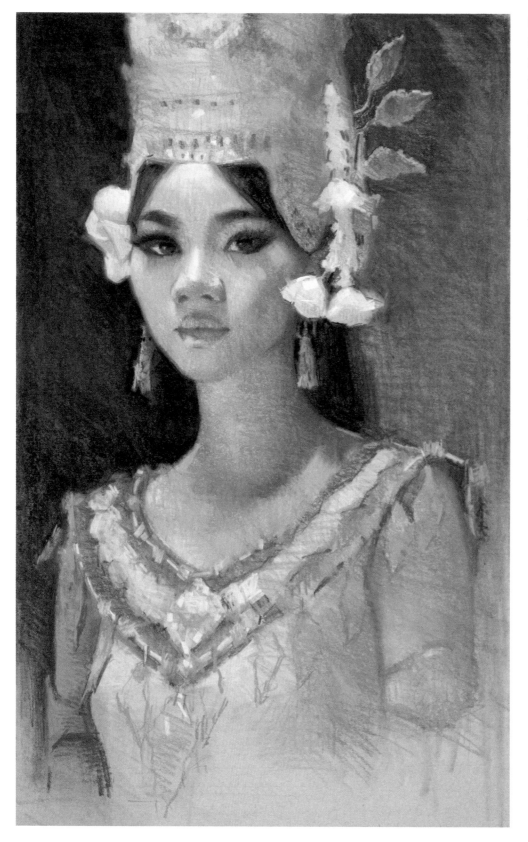

Continue to refine the drawing by adding more detail in the flowers, features, and jewelry. Add a lot more brown and black to push the darks to full strength. Blend with stumps to get that soft, rounded turn of the forms.

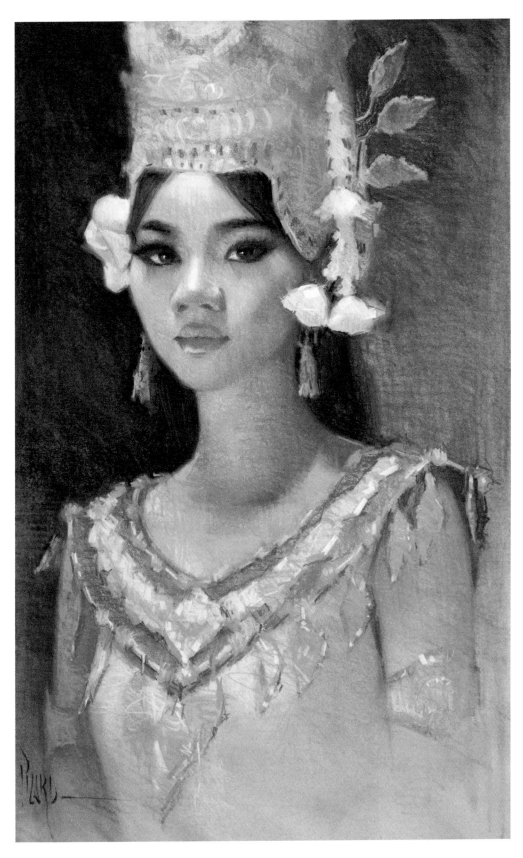

In the final stage of refinement, add highlights with white hard pastel sticks, and develop the golden ornamentation on the chest piece. Create a suggestion of detail on the headdress by adding accent marks there. Final dark and light accents in the face bring this portrait study to a wonderfully warm and radiant finish.

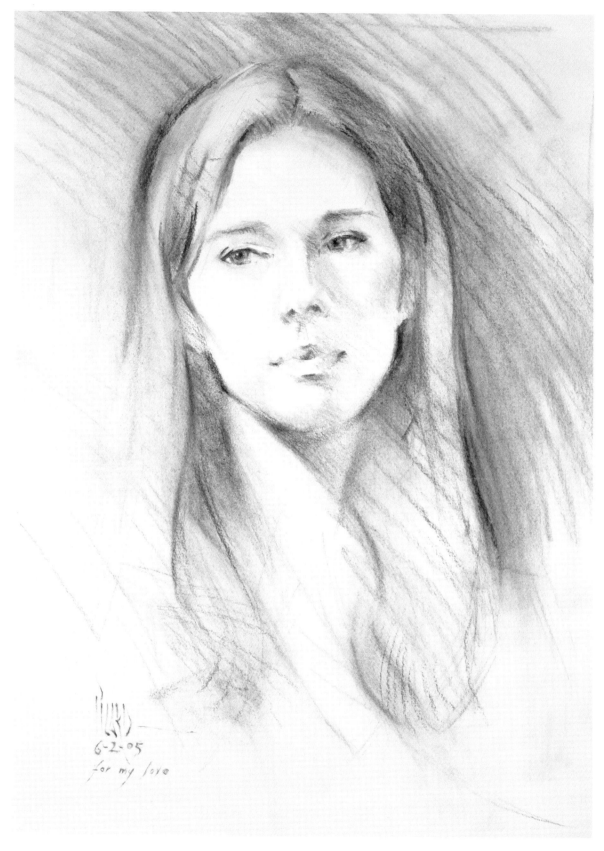

"For My Love," charcoal and white chalk on buff paper.

I created this life study of my wife, Mirjam, during a weekly portrait group I attended. On my anniversary in 2005, Mirjam sat for the group that night so we could be together.

What's Next?

HOW TO CONTINUE YOUR STUDY

These final routine habits will serve to encourage and develop your working routine on a day-to-day and week-to-week basis. If you implement them into your regular work rhythms, then your drawing ability is sure to grow in leaps and bounds, and your creative voice will begin to speak volumes in no time. What a privilege it has been to share this journey with you. Now keep drawing!

PRACTICE, PRACTICE, PRACTICE! You've got to prioritize the goal of learning to draw. Get out your calendar, and schedule regular time to draw. Make it a priority, and build it into your routine, just like exercise or daily meals. Skill develops through consistent practice! Carve out the time to draw regularly every week. Start early rather than late, and try doing one sketch a day—every day—for a month.

DRAW FROM LIFE REGULARLY. Drawing from direct observation of nature is one of the very best ways to improve. Carry a sketchbook and a pencil pouch with you so you can sketch anywhere you go.

GET FEEDBACK AND ENCOURAGEMENT. Why not connect with other artists in your area? Consider joining a local weekly life-drawing sketch group to develop a consistent habit of working from life. Your connection with other working artists will provide accountability and encouragement in the development of your work.

COPY THE MASTERS. One of the best ways to learn technique is to study the great drawings and paintings of art history. Choose a drawing that you absolutely love and try to copy it, stroke for stroke, tone for tone. This process of imitation will impart volumes of drawing wisdom to you as you seek to understand how the artist accomplished such a beautiful study.

About the Author

Alain Picard earned a BA in illustration from Western Connecticut State University and went on to study at the Art Students League of New York. Alain cites Sargent, Degas, and Sorolla among his artistic influences. A love of light and beauty are immediately apparent in his pastel and oil paintings.

Alain's work has been featured in such publications as *The Artist's Magazine* and *Pastel Journal*. He's garnered top awards throughout the Northeast in esteemed exhibitions, including the Portrait Society of America, the Hudson Valley Art Association, the Connecticut Society of Portrait Artists, the Connecticut Pastel Society and the Pastel Society of America. Alain is a Signature Member of the Pastel Society of America as well as the Connecticut Pastel Society where he served as president from 2012 to 2014. In 2004, *The Artist's Magazine* highlighted Alain as one of 20 contemporary artists "On the Rise." He later won the Best Portfolio Award at the 2009 Portrait Society of America Conference in Washington, DC.

A frequent workshop instructor and demonstrator for art associations, schools, universities, and museums, he recently demonstrated at The Metropolitan Museum of Art and the National Arts Club in New York City. In an effort to share his passion for art with others, Alain recently published two books, *Pastel Basics* and *Mastering Pastel*, and is featured in a growing collection of instructional art videos. Alain lives with his wife and two sons in Southbury, CT.

I dedicate this book to my wife, Mirjam. Through every season and sacrifice this journey has taken us, you have remained faithful. For that and so much more, I love you.